DRAWING DARK FANTASY

Creating Monsters, Madness, and All Manner of Nightmarish Imagery

Steve Beaumont

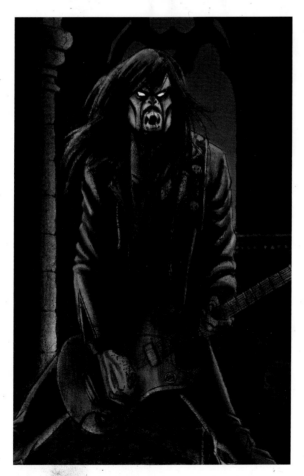

Dover Publications, Inc.
Mineola, New York

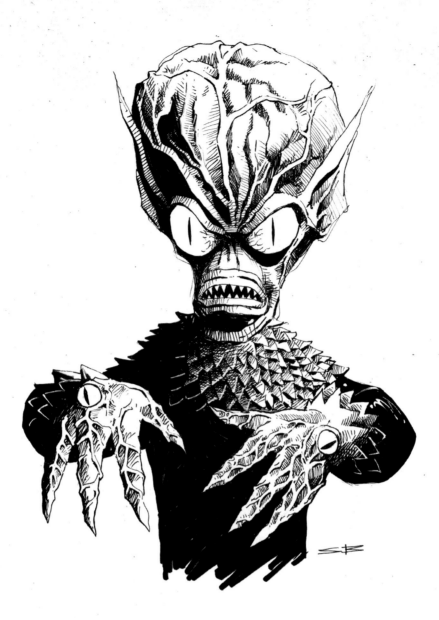

Bibliographical Note

This Dover edition, first published in 2018, is an unabridged republication
of the work originally published by Arcturus Publishing Limited, London, in
2014. The text has been emended to conform to American spelling and usage.

International Standard Book Number

ISBN-13: 978-0-486-82928-9
ISBN-10: 0-486-82928-6

Manufactured in the United States by LSC Communications
82928602 2018
www.doverpublications.com

CONTENTS

INTRODUCTION Page 4

MATERIALS Page 7

SUCCESSFUL FIGURE DRAWING Page 10

PERSPECTIVE Page 17

LIGHTING Page 18

COLORING Page 20

EXERCISES

Exercise 1
DRAGON'S LAIR
Page 22

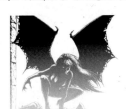

Exercise 2
CREATURE
OF THE NIGHT
Page 36

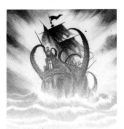

Exercise 3
THE KRAKEN
Page 46

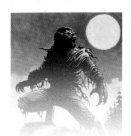

Exercise 4
WEREWOLF
Page 58

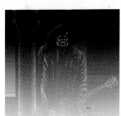

Exercise 5
ROCK 'N' ROLL
VAMPIRE
Page 70

Exercise 6
WILD WEST
REAPER
Page 82

Exercise 7
HALLOWEEN
Page 90

Exercise 8
SEA CREATURE
Page 104

SKETCHBOOK Page 118

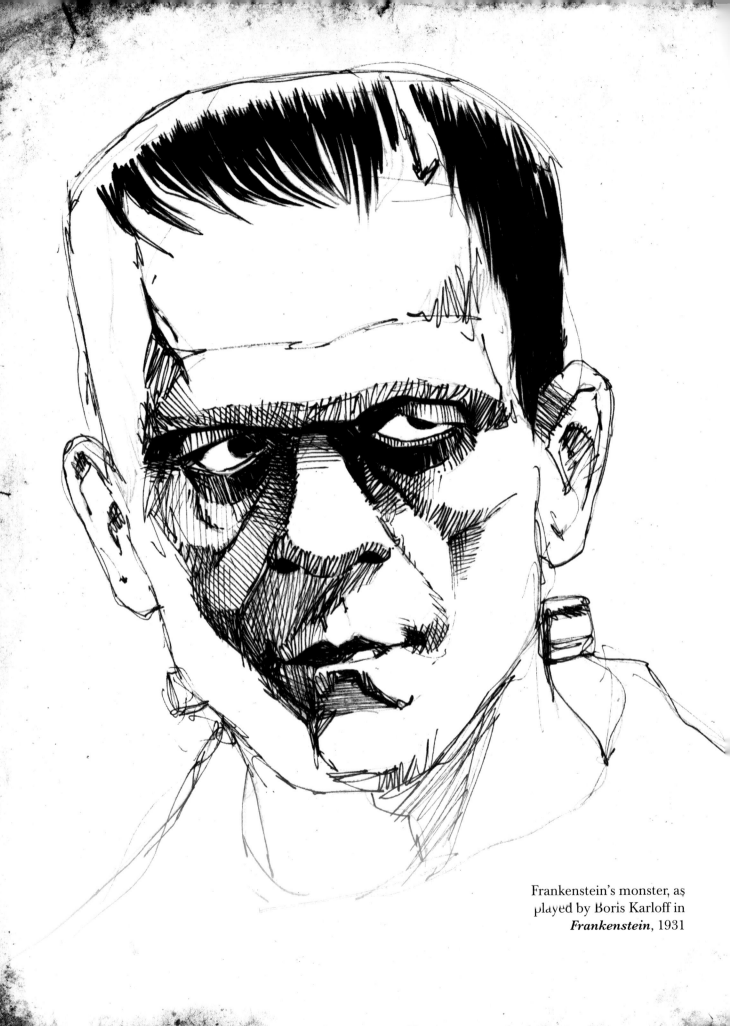

Frankenstein's monster, as
played by Boris Karloff in
Frankenstein, 1931

INTRODUCTION

What is it about fantasy art that so many find appealing? Is it that it covers so many different genres, from horror and science fiction to swashbuckling, swords and sorcery? Is it that it offers the opportunity to engage with extraordinary characters and creatures in extraordinary worlds? Is it because there are no barriers and that anything is possible? The answer is that it is all of these things, and every individual enjoys different aspects of the genre. In this book we will explore a small collection of some of those characters and the worlds they inhabit and in the process create some exciting fantasy art.

I have had a lifelong love affair with comics, books and films dealing with themes of fantasy. As a child, I enjoyed nothing more than reading DC Comics' *Batman* series drawn by Dick Sprang, the first artist to inspire me to produce a piece of fantasy art. Later, motivation was provided by Jack Kirby and Frank Frazetta's art. In my teenage years, Frazetta's work opened up all kinds of possibilities for fantasy drawings, based upon and inspired by my favorite TV shows and films, including *Doctor Who, The Outer Limits, The Twilight Zone, Frankenstein, The Wolfman* and *Creature from the Black Lagoon*.

I have been professionally providing illustration, concept art, storyboards and (occasionally) comic book art for the past 20 years or so. I have had no professional tutoring: everything I have learned has been self-taught, proving that anyone, with practice, can produce fantastic and fantastical art. What I will be passing on to you within the pages of this book are some of the techniques and approaches I have developed, either by accident or by watching other artists at work, during my professional career.

I also teach a "how to draw fantasy art" class, and this book incorporates some of the themes and tutorials used there. It is a companion book, if you like. During the years the class has been running, I have successfully enabled a number of students to compile a portfolio of work, which they showed to talent scouts at comic conventions and eventually led to their getting commissions from Marvel Comics.

What I will be showing you in the following pages are easy-to-follow steps that will guide you through the process of producing a piece of fantasy art. I have not gone into every minute detail—this is because, as I keep telling my students, I do not want to encourage you to copy my style and exactly how I draw as if it were the only way, as we all have to find our own path forward.

This book is not aimed at the professional or semi-professional artist; it is more for those (the amateur, if you like) who enjoy drawing and are fans of fantasy art and are looking for some tips and ideas that will enable them to take their drawing skills a stage further. I thought it would also be helpful to document any changes I thought of as I went along. Unlike drawings I produce for a client, which are meticulously planned and go through various stages of development, I have approached these artworks as I

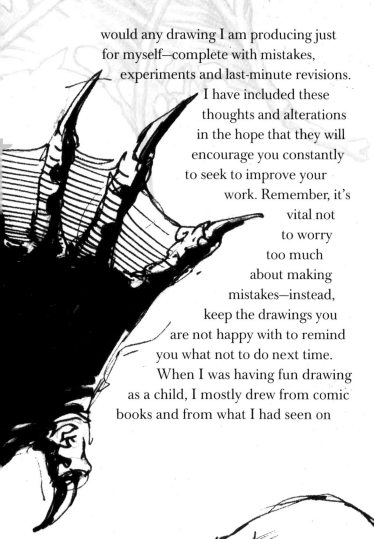

would any drawing I am producing just for myself—complete with mistakes, experiments and last-minute revisions. I have included these thoughts and alterations in the hope that they will encourage you constantly to seek to improve your work. Remember, it's vital not to worry too much about making mistakes—instead, keep the drawings you are not happy with to remind you what not to do next time. When I was having fun drawing as a child, I mostly drew from comic books and from what I had seen on TV or at the movies. Basically, I drew what pleased me and what I was interested in, and this is true of most fantasy artists. For instance, Frank Frazetta is a sports fan, and, from what I have read, something of an athlete, and this is evident in his work. Adi Granov has a love of automobiles, aircraft and machinery, and these are strong features in his drawings. Claire Wendling clearly has a love, understanding and passion for wildlife and nature. All draw what they are passionate about, and this makes them better artists, in my opinion.

Personally, I love horror and sci-fi movies and comics, and 70 percent of my daily work is related to these themes. I enjoy working with this subject matter and hope you find drawing it as fun and exciting as I do, and that it will encourage you to become a better artist.

Have fun!

Steve Beaumont

The prehistoric beast in *Creature from the Black Lagoon*, 1954

MATERIALS

A good artist is able to use experience and ability to draw something great with even the most basic of tools. However, for the less experienced artist to progress well and achieve the very best results (especially at a professional level), good-quality equipment is required. Cheap materials will often hinder not only your development but also the quality of your work.

If you ever go to a comic convention and watch artists draw, you will notice that each artist has his or her preferred brand of pen or pencil. I often try out new materials after watching another artist work with a tool that I have not used before. Often this new implement will push my drawing ability forward, but ultimately it all comes down to personal preference and budget.

This section covers some of the tools I have tried and tested and used for the drawings in this book. Good-quality, affordable and readily available, they should meet most requirements, although over time you should experiment to see which ones you find work best.

PAPER

With so many different surfaces and weights of paper on the market, it would be difficult to mention them all here. If I am working in pencil I use a variety of weights and surfaces of cartridge paper, depending on the desired type of pencil line I am trying to achieve. I can recommend Winsor & Newton cartridge paper. I use 180gsm for general rough sketching and 300gsm for finished artwork. I use a medium rough-surface paper for pencil work that I want to blend, as this gives excellent effects and is also good for dry brushwork when using ink. I use a smooth-surface paper for work requiring a precise, crisp line. Arches Aquarelle watercolor paper is also nice for pencil work, especially if you are combining an ink or watercolor wash with your drawing.

When working with paint, the type of paper required varies depending on the paint used and the finish that is required. In general, I like to use Langton Prestige Hot Pressed paper 300–400gsm, Saunders Waterford Hot Pressed paper 300–400gsm and Arches Aquarelle Watercolor Paper 300gsm all surfaces. These are just my preferences, however, and you should try out others. For most brands, the following abbreviations are given: HP = Hot Pressed (smooth finish); NOT/CP = Cold Pressed (slightly textured); Rough Surface = rough.

PENCILS

I depend on a variety of pencils, but the ones I use on a daily basis are the Staedtler Mars Lumograph HB pencil or a Staedtler Noris HB pencil. The Mars Lumograph is a high-quality artist's pencil, while the Noris is more of an office pencil. I also use Faber-Castell Pitt Graphite Pure HB and 6B and Wolff's Carbon pencils, which deliver rich black tones. More recently I have been using Blackwing pencils, which have a bit of a cult following and are deemed by some to be the finest pencils ever made. I have also started using Prismacolor Col-Erase pencils, which are high-quality erasable colored pencils that glide across the surface of the paper well and leave a very clean line. I started using Prismacolor Col-Erase pencils for concept work and rough sketches as the line work is strong, yet easily removed with minimum effort, meaning that I can continue revising the drawing without damaging the paper. They also come in a wide range of colors.

Staedtler Mars Lumograph HB pencil (left) and Staedtler Noris HB pencil

BLENDERS AND ERASERS

I sometimes use Derwent paper stumps for blending, but I have also used unbranded and economy blenders to good effect. I use tissue paper wrapped around my finger for some blending situations.

There are many different erasers on the market, but I find Winsor & Newton Kneaded Putty Rubbers and Staedtler plastic erasers to be very reasonable quality. Putty rubbers can be moulded and twisted into different shapes so that you can erase fine points and corners. The classic Staedtler plastic eraser is a good all-around tool and very reasonably priced. The Derwent battery-powered eraser is useful for rubbing out small areas of artwork quickly and precisely.

Derwent battery eraser

Staedtler plastic eraser

Winsor & Newton putty rubber

Derwent paper stumps

MARKERS

Marker brands have come and gone in my years as a professional artist. These days I almost exclusively use Copic markers because they offer a flat coverage of ink and a variety of nibs (making them highly versatile); replacement inks and nibs are available. The color range is also impressive. Other brands, such as Prismacolor, also produce high-quality markers, so it is worth exploring and making up your own mind.

Copic markers

INK PENS

I have been using Faber-Castell Pitt artist pens for a long time now and still like working with them. I also like Copic Multiliners and the Pentel Brush Pen.

Faber-Castel Pitt artist pens are available in a variety of nib sizes, indicated by the letter or letters on the side of the pen: XS = Extra superfine, S = Superfine, F = Fine, M = Medium and B = Brush. Recently they have brought out the Big Brush pen, which has a larger brush nib for a heavier line and greater coverage. They are disposable; replacement nibs and ink cartridges are not produced.

Copic Multiliner pens are available in a number of nib thicknesses, ranging from 0.03–0.7 to brush, and are refillable and can have their nibs replaced. The Copic Multiliner is a technical pen that produces very precise line work. Both brands are excellent in terms of value for money and performance.

Faber-Castell Pitt artist pens

INK

High-quality India ink is available online and in good craft stores. I work with various brands, including Dr. Ph. Martin's Bombay India Ink, Sennelier Black India Ink (also known as Chinese Ink), Higgins Ink and Stephens Black Drawing Ink.

Copic Multiliner pens

GOUACHE

When I produce a painted illustration, I normally use gouache as it is a versatile medium and dries quickly. My preference is Winsor & Newton Designers Gouache, which is very good quality.

BRUSHES

I use Winsor & Newton sable brushes for inking and painting. Sable brushes are expensive, but they last longer than mixed-fiber and nylon brushes, and they also carry more ink and produce a more controllable line. There are many different thicknesses available in flat or round shapes; if you work with paint regularly it is worth investing in a range. You can buy sets of mixed-fiber brushes very cheaply, and could start with those while you work out which sizes and shapes you use most, and then invest in sable versions of a couple of your preferred brushes.

Winsor & Newton sable brushes

Successful Figure Drawing

Figure drawing can be a huge stumbling block for many beginners and even for some people who have been drawing for a while. When it comes to drawing dragons or other beasts, there often appears to be no problem at all, but when a well-balanced figure drawing is required, issues can arise. In the next pages I offer some of the approaches to figure drawing that have helped my students gain more confidence. This section is intended to give a basic overview of the techniques so that they can be applied assuredly to imaginative drawings.

BASIC ANATOMY

Humans come in all shapes and sizes and with all kinds of variations that make each one unique, but for the purpose of getting started on producing a balanced and well-proportioned figure, let's look at the basic muscular, human form. As a rough guide, the adult human form is about seven-and-a-half heads tall. However, it is common practice to exaggerate the proportions of fantasy characters, and the imagined figure is more usually eight-and-three-quarters heads tall, whether it is male or female (Figure 1).

I, as well as my students, have found it helpful to have a rough knowledge of the skeletal structure of our bodies. I can draw a figure better if I understand how it should look and how it works, otherwise I am merely guessing and filling in the vague areas using incomplete information, which will be evident in the end result. The human skeleton comprises about 206 bones, some of which are labelled in Figure 2. Memorizing the names for each and every bone is not essential for successful figure drawing, but it is helpful to be familiar with the names, proportions and joint structures of ones that are most important for drawing the human form.

It would take far too long to draw a complete skeleton every time you wanted to draw a figure, and, moreover, it is not necessary. Instead, you can simply break down the skeleton into some basic, manageable shapes or lines, and this should enable you to achieve some pleasing results.

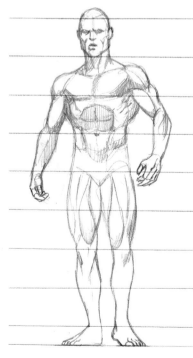

Figure 1

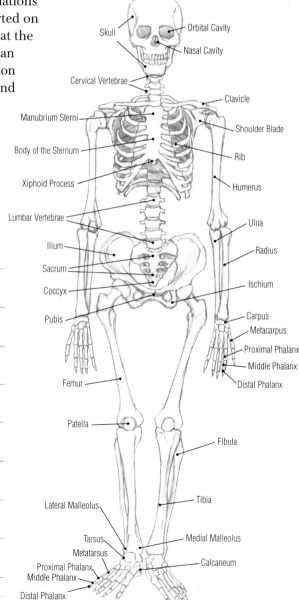

Skull
Orbital Cavity
Nasal Cavity
Cervical Vertebrae
Clavicle
Manubrium Sterni
Shoulder Blade
Body of the Sternum
Rib
Xiphoid Process
Humerus
Lumbar Vertebrae
Ulna
Ilium
Radius
Sacrum
Coccyx
Ischium
Pubis
Carpus
Metacarpus
Proximal Phalanx
Middle Phalanx
Distal Phalanx
Femur
Patella
Fibula
Lateral Malleolus
Tibia
Tarsus
Medial Malleolus
Metatarsus
Calcaneum
Proximal Phalanx
Middle Phalanx
Distal Phalanx

Figure 2

BREAKING DOWN THE FIGURE

My students have achieved good results with three approaches to figure drawing. Some students responded well to stripping down the skeleton to a simplified stick form as shown in Figure 1, while others had more success using construction shapes—an assortment of ovals, cylinders and spheres—to construct a figure, as shown in Figure 2. I personally go about figure drawing by loosely sketching the form and feeling my way around the shape as I go along, as shown in Figure 3, and some students have also found using this approach useful. Whichever method you choose, you should be able to arrive at a completed figure, as shown in Figure 4.

With all these methods, the main points to keep in mind are the size of the head in relation to the body (page 10, Figure 1) and the length and position of the arms and legs. The arms can be divided into two roughly equal lengths. In reality, the upper leg (thigh) is generally longer than the lower leg (shin and calf area). However, when creating fantasy art, I tend to draw

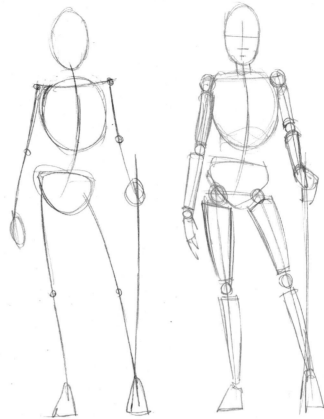

Figure 1　　　　　**Figure 2**

Figure 3　　　　　**Figure 4**

them both about the same length, but with the upper leg wider and thicker-set than the lower leg. The torso can be put together using an oval (I sometimes draw a shape that resembles a rib cage, as in Figure 3) for the rib cage and a shape resembling a pair of briefs for the pelvis.

It is good practice to study yourself in the mirror—preferably a full-length one —to become aware of how certain poses affect parts of the body. For example, try standing with both legs straight with your body weight centered over them, then transfer your body weight to just one leg. Notice the effect this movement has on the other leg. What has happened to the stance? What differences do you notice? Has the shift of weight affected other parts of the body, such as the pelvis, your shoulders or the curve of your back and spine? What about the angle of your head? Recreating what you see in the mirror in your figure drawing will make the artwork that much more convincing. (You could take a photo of your reflection in a certain stance to refer to while you are drawing.)

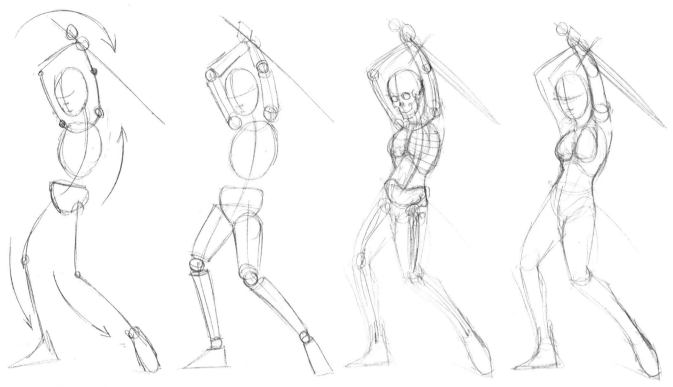

Figure 5 **Figure 6** **Figure 7** **Figure 8**

Figures 5–8 are examples of how the different methods outlined on page 11 can be used to create a dynamic pose. Sometimes it helps to think about the direction of the twists and turns within a pose to help capture the movement, and these forces can be indicated by arrows, as in Figure 5.

I have noticed that some students pay too much attention to the construction shapes themselves in their very early work. The shapes are there only as a guide and can be drawn as loosely as you like; it should only take a matter of seconds to draw them, not minutes. The figure drawing is the focus. I understand that when starting out on a journey to develop your drawing ability every new piece of information seems important, and sometimes it is easy to lose sight of the bigger picture. With this in mind, I often encourage students to approach figure drawing using the loose, scribbly style shown in Figures 9, 10 and 11. Approaching figure drawing in this way may allow your drawing to flow better, making the pose less rigid.

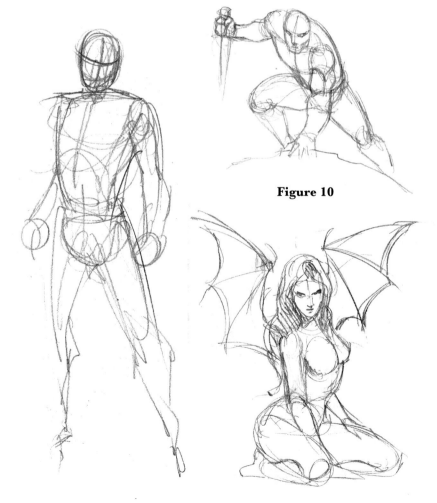

Figure 10

Figure 9 **Figure 11**

DRAWING MUSCLES

Once the basic framework of the figure has been established, you can go on to build the shapes of the muscles. Muscle structure is something a lot of beginners struggle with. This is usually because they have a limited understanding of the human form and how it works. Also, most of us can't precisely recall how, for instance, abdominal muscles look when a body is in a certain position. We can easily recognize various parts of the anatomy, but recreating them accurately on paper is another matter; recognition and observation are two very different things.

Fortunately this is easily remedied. We all have muscles (otherwise we would just collapse!), and they do not have to be well developed for

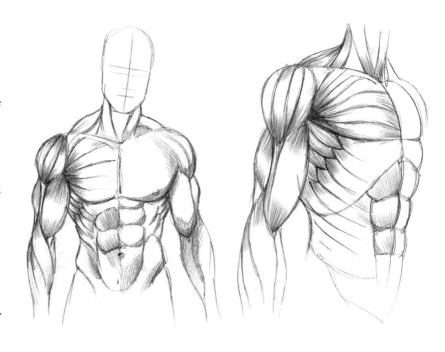

Figure 1 **Figure 2**

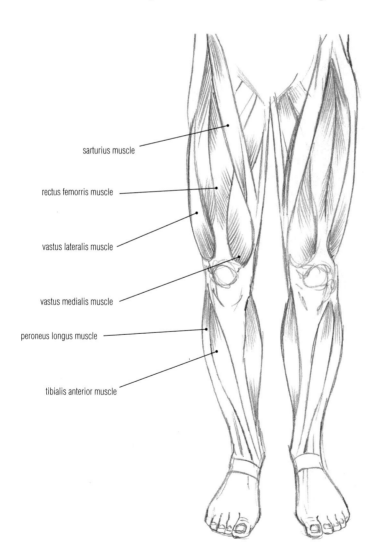

sarturius muscle

rectus femorris muscle

vastus lateralis muscle

vastus medialis muscle

peroneus longus muscle

tibialis anterior muscle

Figure 3

you to study and observe how they work within the body. This is why I recommend studying your own form in a mirror. I appreciate that some people may be self-conscious, but once you get over your initial insecurities you will find posing in the mirror an invaluable practice. Alternatively, if you have a friend who will pose for you, then that is also a fantastic way to study the human form. Life-drawing classes could be a good idea, although you should bear in mind that some lessons are more about abstract work and lighting than the actual study of anatomy.

Figures 1 and 2 on this page show how the biceps, triceps, shoulder, chest and abdominal muscles are drawn as interconnecting shapes, while Figure 3 shows how the various muscles in the leg fit together. Whether large or small, the muscles all begin and end with a point which either overlaps another muscle or ends where a muscle starts. They contract and expand to create different shapes. When a biceps muscle is outstretched, it appears long and thin, but when the arm is bent and the muscle is flexed it becomes short and wide.

DRAWING THE HEAD

Drawing the head need not be a difficult task. If you think of the skull as a sphere with sections removed from either side (Figure 1) and a roughly cubed shape attached to one of the bottom quarters, then you will be able to create the basic shape (Figure 2). If you look at the sphere from the side and divide it into quarters, the center line is roughly where the eyes sit. If you continue a line from the bottom of the sphere, it will mark the position of the bottom of the nose. The jaw line runs at an angle away from the bottom of the sphere. If you mark a line between the nose and the bottom of the jaw, you will have the position of the mouth (Figure 3).

This technique gives you the guidelines for positioning simple features in the correct place (Figure 4). You now need to practice drawing the features themselves, whether by looking in a mirror or by doing the exercises in this book. With patience and practice, you will perfect your technique, and the curves and shapes of features such as the eyes, nose and mouth will come naturally.

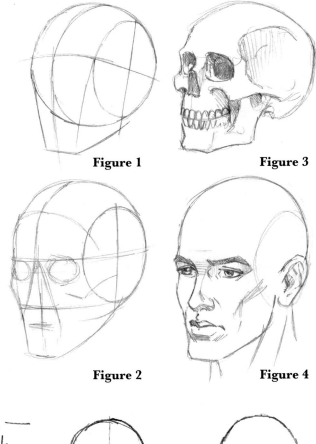

Figure 1 **Figure 3**

Figure 2 **Figure 4**

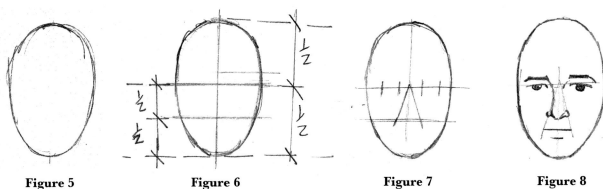

Figure 5 **Figure 6** **Figure 7** **Figure 8**

If, however, you are struggling to use the ball and cube technique, there is an alternative, simpler approach you could try. Draw an oval (Figure 5). Remember what I said earlier about being too technical about initial shapes—just sketch some ovals and divide them into quarters (Figure 6). The central horizontal line is where the eyes should sit. Now draw a line between the center line and the bottom

of the oval. This is where the bottom of the nose will come to. Draw a line between the nose and the bottom of the oval. This is where the mouth will sit.

As a rough guide for positioning the eyes, divide the face widthways into five equal parts; the second and fourth space will give you the position of each eye (Figure 7). To work out the width of the nose and mouth, draw two diagonal lines from the bridge of the nose, between the eyes, down towards the bottom of the oval. The points where the diagonal lines cross the line for the mouth denote the outer edges of the mouth (Figure 8). Of course, these are just rough guidelines for you to follow. Once you feel more confident about drawing the face, you will be able to create many different shapes and sizes of faces.

Figure 9 shows how just a few simple lines can be used to convey different expressions.

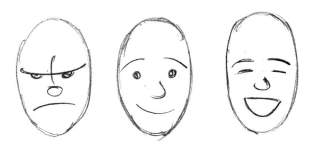

Figure 9

Figures 10–15 show a more detailed breakdown of how to draw the head and face. More often than not I use an oval (Figure 13) for the head. If I am drawing a three-quarters view I may use the structure shown in Figure 1.

As usual, I have divided the width of the face into five equal parts (Figure 11) to give me the position for the eyes, so that they are not too far apart or too close together. To gauge the width of the nose and mouth I draw a triangular shape from the bridge of the nose (Figure 12). This should not be too precise or rigid—some of the things that make a face interesting are the features which do not adhere to the generic grid. Once you become more skilled at drawing faces, you will naturally begin to have fun slightly distorting the proportions.

When drawing hair, I go for uncomplicated shapes that complement the face and look natural (Figure 13), as I find this gives the best result. I am influenced by the way Disney artists draw hair in animated feature films, such as the 1995 film *Pocahontas* which has some lovely stylized flowing hair that I often incorporate into my drawing.

With all the guidelines still prominent, the face is not looking especially attractive. Remove the guidelines and begin to soften the features, making the eyes, nose and mouth prominent (Figure 14). Notice that I have reduced the amount of lines for the nose. It is best to keep line work on faces simple—heavy work around the nose can age the character. Sometimes defining the nose by drawing a simple line, as if the face is being lit from one side, is all that is required. When drawing the female face, use soft curves for the eyelids, lashes and mouth.

You can now shade in the hair (Figure 15), keeping the line work simple and leaving white highlights to give the impression that the hair is glossy. Once you are happy with the drawing, carefully erase all the guidelines and add any final touches to the shading.

Figure 10

Figure 11

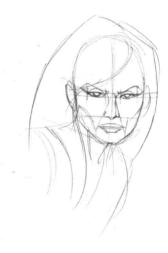

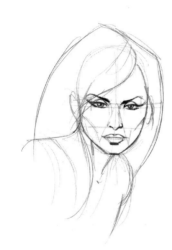

Figure 12

Figure 13

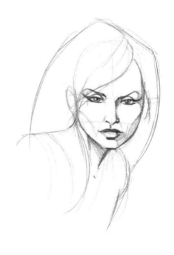

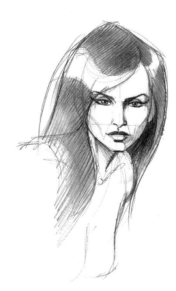

Figure 14

Figure 15

DRAWING FEET

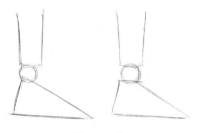

Figure 1

Feet can be a stumbling block for many artists but, as with other parts of the anatomy, they can be broken down and simplified. Looking at the foot from the side, think of it as a right-angled triangle and build the foot around that shape (Figure 1). The toes are a lot shorter than the fingers of the hand, so I tend to sketch rough spheres or ovals for the toe ends and to draw in stumpy cylinder shapes between the spheres and the triangle of the foot. The shape of the underside of the foot can be approximated using a top-heavy figure-of-eight (Figure 2). Study and draw your own feet in a neutral position (Figure 3) and then see how the shape varies when you walk or curl your toes (Figure 4). Try to observe carefully, absorb what you see and apply it to your drawing. This is the best way of learning to draw anything.

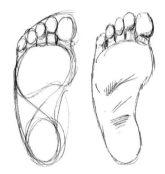

Figure 2

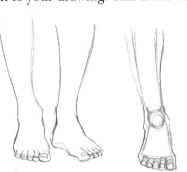

Figure 3

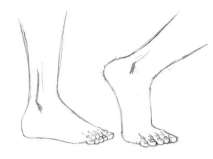

Figure 4

DRAWING HANDS

I learned to draw hands using a classic, tried-and-tested method and this remains one of the best ways to approach drawing these complex body parts. Using construction shapes is a very good start, especially when viewing the hand from above (Figure 5). The back of the hand is essentially a square shape. Each finger has three sections, which can be represented by cylinders. These are connected to one another by two joints along the finger, and at the knuckle, where a small sphere can be used. The thumb is shorter than the fingers and has only one joint. The area where the thumb joins the hand is represented by a triangle. This helps me to position the thumb correctly in various poses.

Once you have completed the construction shapes you can start to flesh out the drawing (Figure 6). Once you are satisfied, erase the construction shapes and add the fingernails and other surface details to the hand (Figure 7).

Figures 8–14 are sketches of hands in various poses, and you can use these as a guide for practicing some of the more difficult views. I drew these using my own hand for reference, either looking directly at it as I drew or at its reflection in a mirror. There is no doubt that hands are difficult to master, but if you start with simple poses and gradually progress to more complex shapes, with practice you will notice an improvement.

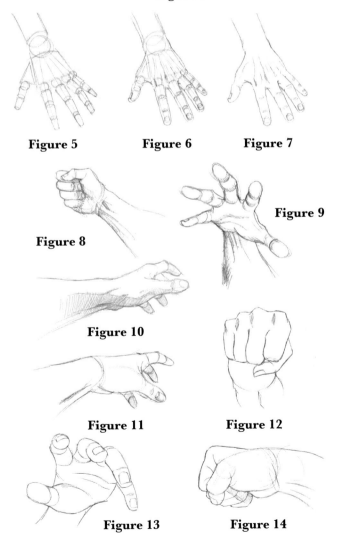

Figure 5 **Figure 6** **Figure 7**

Figure 8

Figure 9

Figure 10

Figure 11

Figure 12

Figure 13

Figure 14

PERSPECTIVE

There are so many subtleties when it comes to drawing perspective that it is impossible to cover everything here, but there are some basics you will need in order to follow the exercises in this book. If you want to develop the use of perspective in your drawings then I recommend you purchase a book that focuses purely on it. There are plenty of good ones out there.

The most common example of perspective is single or one-point perspective (Figure 1), which gives an impression of depth. Looking at the cube straight on you can see that the sides on the top seem to draw closer together the further back they go. If these converging lines are extended beyond the back edge of the cube they will eventually meet at what is called the vanishing point. The level at which they meet is the horizon or "eye line." This single-point perspective can also be seen in Figure 2. Notice how the road narrows in the distance towards the horizon. The same would occur in a picture of a railway track or canal.

While single-point perspective deals with the foreshortening of one dimension of an object, two-point perspective deals with the foreshortening of

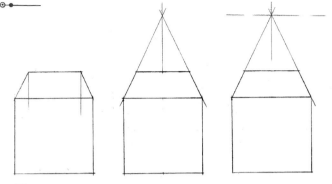

Figure 1

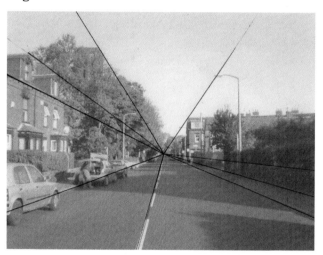

Figure 2

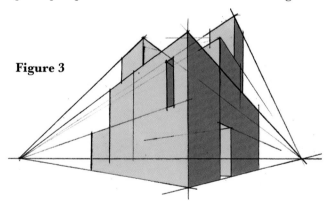

Figure 3

Figure 4

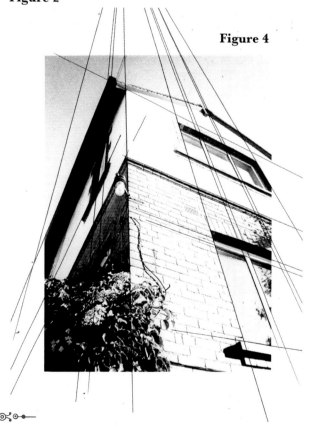

two dimensions and gives an indication of the width of the object along both visible sides. This occurs when a corner point faces the front (Figure 3). If the perspective lines are extended, they eventually meet at two vanishing points on the horizon.

Three-point perspective deals with the foreshortening of three dimensions of an object and occurs when the viewpoint is close to the object, looking up. The third perspective point is a vertical one and gives the impression of height. Using three-point perspective will enable you to draw dramatic structures, such as the one in Figure 4.

LÍGHTÍNG

Understanding light and shade and where to place highlights and darkened areas can make or break a good piece of illustration. Figure 1 shows how the position of an object in relation to a light source affects the shadow cast by the object. I learned about shading in relation to light by drawing an object lit by a single light source, the position of which changed in each sketch (Figure 2). This simple technique helped me develop an understanding of how light affects a picture. Face A is lit by a soft front-on light source. Face B is lit by a light source to the side of the head, face C is lit by a low light and face D is lit from above.

Of course, lighting is a lot more complex than it appears in these examples and there is often more than one source. In addition, in a confined space a single light source can bounce off the surrounding walls to create additional light sources. This can be useful for

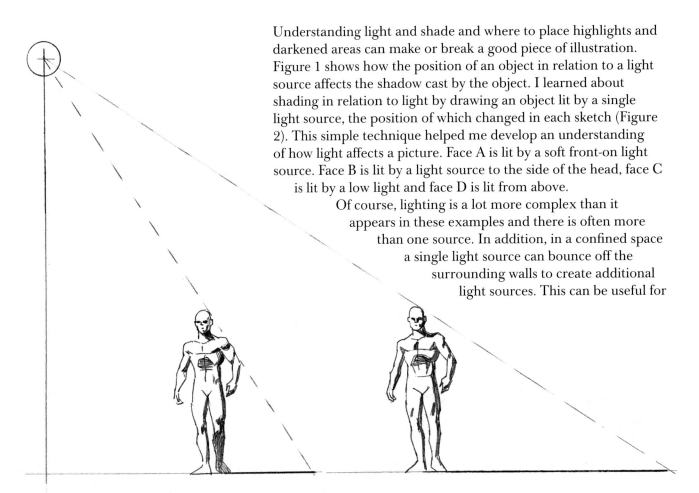

Figure 1

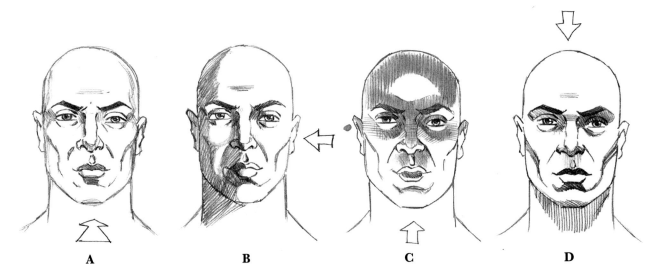

A B C D

Figure 2

Figure 3

highlighting different areas of an object to make them stand out from the background.

Figures 3 and 4 are sketches I produced while on vacation. I intensified the shadows created by the sun to a solid black. This enabled me to create bold, striking images. Notice how the use of solid black in Figure 4 makes the tree trunk in the foreground stand out and gives a more three-dimensional appearance to the piece.

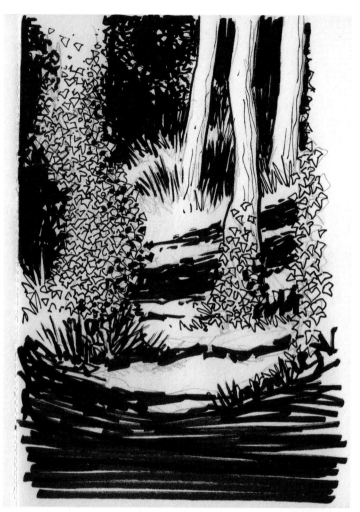

Figure 4

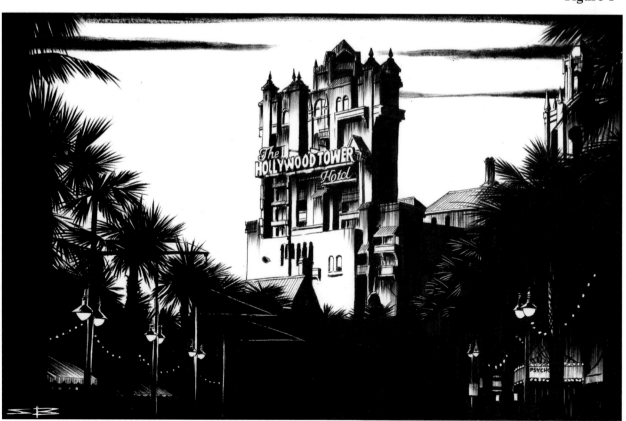

Figure 5

COLORING

For the best part of my career I have been a traditional artist. By 'traditional' I mean that I usually work with pencils, inks and paint on paper, board or canvas rather than creating images digitally. About 70 percent of my concept art and storyboard work is colored using Copic markers and sometimes colored pencils, but more recently I have begun coloring my work using Photoshop.

This change came about by chance, when I placed an order for some materials but only a few were immediately available: the other items arrived later but not in time for me to meet a work deadline, so I decided to color the piece digitally. At the time I used a mouse, which was a slow and clumsy device for certain parts of the coloring. However, the final piece pleased the client so much that I invested in a Wacom graphics tablet. I have since discovered that working with a tablet enables me to work more quickly and saves a lot of money that I would normally spend on materials. I still consider myself a traditional artist, but today more often I merge traditional and digital techniques, gaining the best of both worlds as they each offer different benefits.

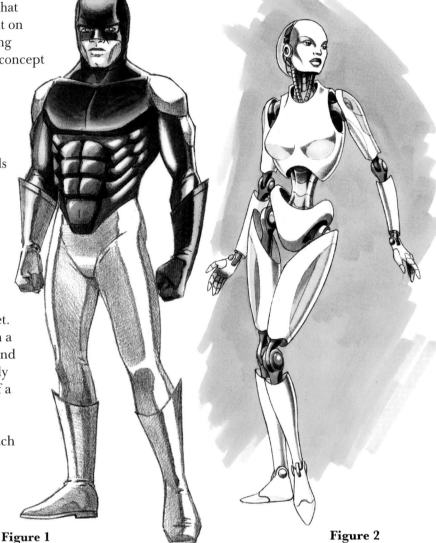

Figure 1

Figure 2

Figure 3

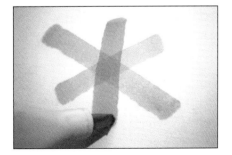

Figure 4

I approach coloring my work digitally in the same way as I would if I were using markers or watercolors and, to some extent, acrylic or oils. I apply a pale wash as a background for the rest of the colors to sit on, which adds depth. I build up the colors using layers, all set to Multiply. This allows colors to interact and blend with the layers. If I were working on a pure white background I could end up with bits of white showing through where the brush strokes are lighter or broken, which would create a brighter, breezier image. This could be fine if that is the effect you want to achieve.

Figure 1 and Figure 2 are examples of traditional concept art, colored using Copic markers. I started by laying down a single flat coat of ink with the pen (Figure 3). Figure 4 demonstrates how I built up the depth of color by applying more layers of the same shade. You should be able to see the strength variations as the layers cross over one another.

COLORING WITH MARKERS VS DIGITAL COLORING

Figures 7–10 demonstrate how markers and digital coloring work in pretty much the same way. The images in the left-hand column were created using Copic markers on paper and the images in the right-hand column were created digitally.

If you closely examine the lines created by the marker, you will see that the ink creates a texture as it soaks into the fibers of the paper. This can lend a pleasing quality to illustrations and concept art in the same way that the random and uneven drying of ink or watercolor washes can. Digital coloring always tends to be cleaner and brighter than manual coloring, which can be desirable. Both methods have their own unique benefits that will enhance your art, and I will be using both in this book.

COLORING AN IMAGE USING PHOTOSHOP

Although I do not give explicit instructions regarding coloring images using Photoshop, or the exact CMYK colors I used, it is helpful to have a rough idea of how to start experimenting with this program. The best way to learn is simply to give things a try; that is the main benefit of digital images—unlike hard-copy drawings they can be replicated and saved as separate files so you can try out infinite variations.

1. Scan the finished drawing and save it as a tiff or psd file. Import this file into Photoshop.

2. Create a new layer (Layer 1), then choose the Fill option and select a shade for the base layer. Adjust the opacity until you are happy with the result. Choose the Multiply option from the drop-down menu, which will insure the layer is transparent.

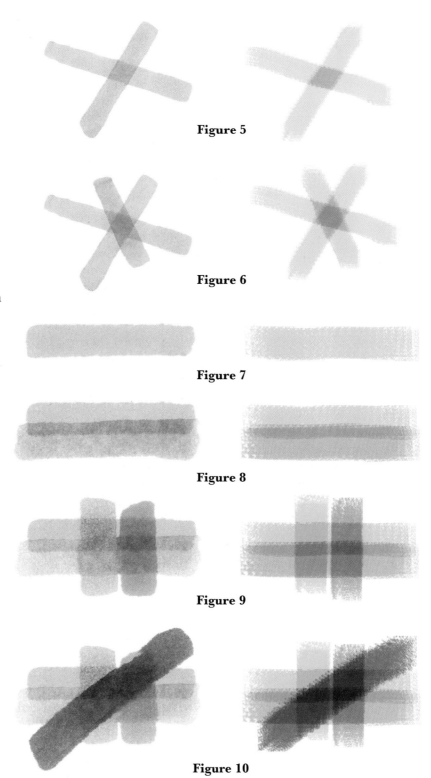

Figure 5

Figure 6

Figure 7

Figure 8

Figure 9

Figure 10

3. Add details to specific areas of the picture using one of the many brushes and the palette of colors available. It is a good idea to create a new layer, set to Multiply, for each level of detailing so that you can amend them individually. There are many brushes available online, but I sometimes create

my own by scanning ink spatters, pencil rubbings and cross-hatching I have produced on paper.

4. To add highlights, use a brush tool set to Normal rather than Multiply, since you don't want highlights to be transparent or to blend with the layers underneath.

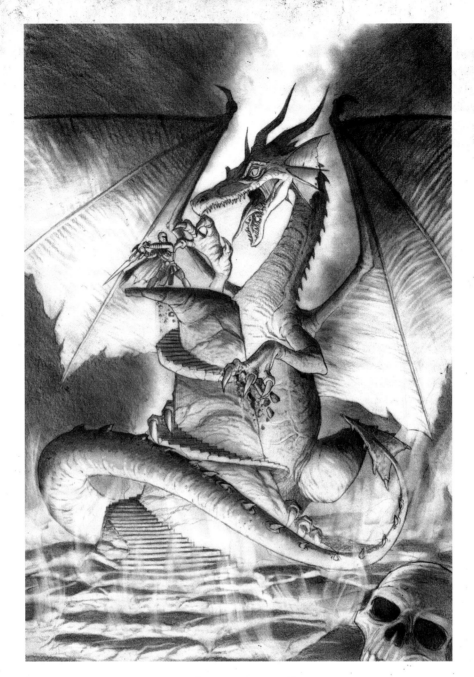

EXERCISE 1

DRAGON'S LAIR

Featuring in the mythology of many countries—including Japan, China, England, Wales, Scotland, France and South America—dragons are one of the most recognized and frequently depicted creatures in fantasy art. Although they are sometimes portrayed as the guardians of fabulous treasure and secret gateways to hidden lands, these memorable beasts are more often shown wreaking havoc on villages and castles or locked in fierce combat with a heroic warrior. For this drawing I have chosen the latter scenario.

This exercise will draw upon the disciplines of figure drawing, composition and lighting and requires a pencil and a piece of paper. I used a Staedtler HB pencil on Winsor & Newton 300gsm cartridge paper.

Before jumping straight into the action I thought it would be helpful, for those of you who have not drawn a dragon before, to look at how relatively easy it is. Also, it will be a good warm-up exercise to prepare you for the main drawing.

I usually start any drawing by producing rough, loose sketches, keeping the line work light so that I can continue to draw over the top of it (Figure 1). I find reducing a subject to simplified shapes can be helpful while you are becoming acquainted with a new form, so I have shown here how the form can be broken down using some red shapes. I have not gone for the usual circles, blocks and cylinders—instead I have roughly drawn an oval for the body and created some pleasing curves for the tail and neck (Figure 2). When sketching the shapes, keep them loose and rough. Try not to become too involved with drawing the shapes—remember, you are drawing a dragon, and that is your focus (Figure 3). Try to let the lines flow. Once you have created a natural-looking pose that you are happy with, you can start to develop the sketch further by adding more detail (Figures 4 and 5).

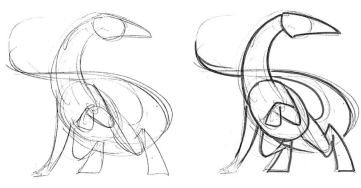

Figure 1 **Figure 2**

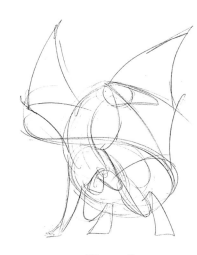

Figure 3

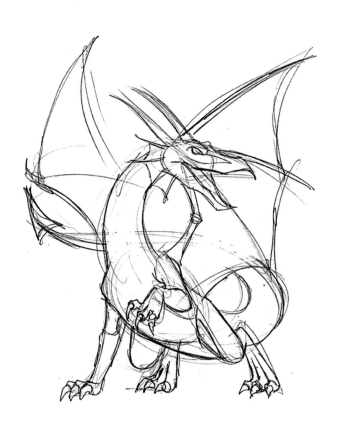

Figure 4

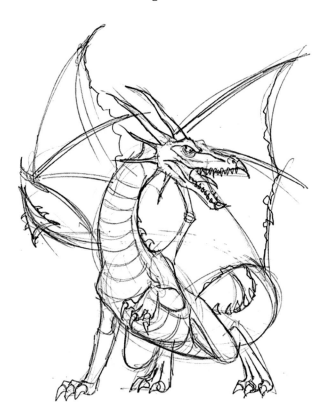

Figure 5

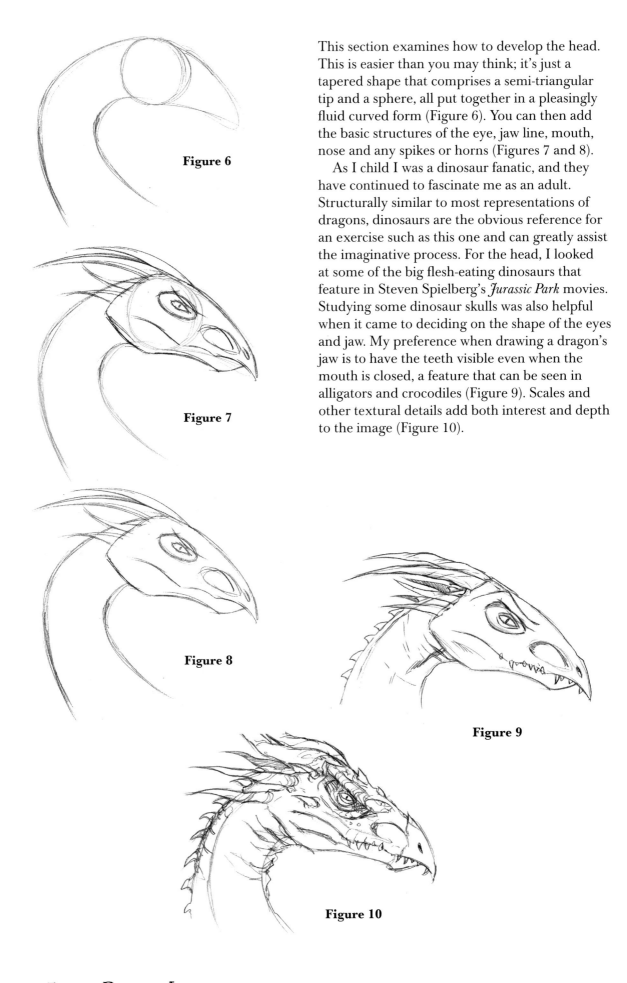

This section examines how to develop the head. This is easier than you may think; it's just a tapered shape that comprises a semi-triangular tip and a sphere, all put together in a pleasingly fluid curved form (Figure 6). You can then add the basic structures of the eye, jaw line, mouth, nose and any spikes or horns (Figures 7 and 8).

As I child I was a dinosaur fanatic, and they have continued to fascinate me as an adult. Structurally similar to most representations of dragons, dinosaurs are the obvious reference for an exercise such as this one and can greatly assist the imaginative process. For the head, I looked at some of the big flesh-eating dinosaurs that feature in Steven Spielberg's *Jurassic Park* movies. Studying some dinosaur skulls was also helpful when it came to deciding on the shape of the eyes and jaw. My preference when drawing a dragon's jaw is to have the teeth visible even when the mouth is closed, a feature that can be seen in alligators and crocodiles (Figure 9). Scales and other textural details add both interest and depth to the image (Figure 10).

Figure 6

Figure 7

Figure 8

Figure 9

Figure 10

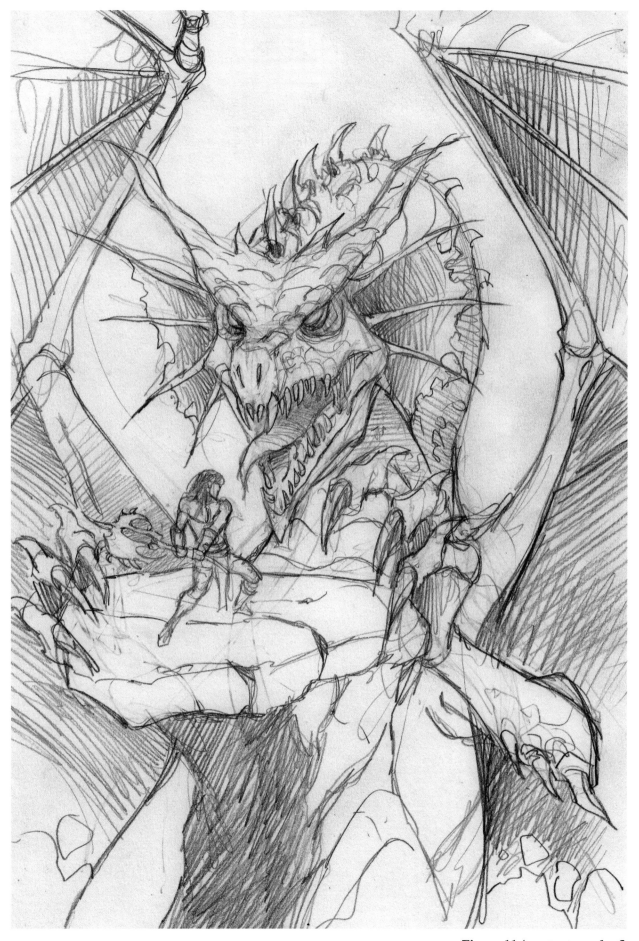

Figure 11 (see text overleaf)

Exercise 1 Dragon's Lair ⚬❈⚬ **25**

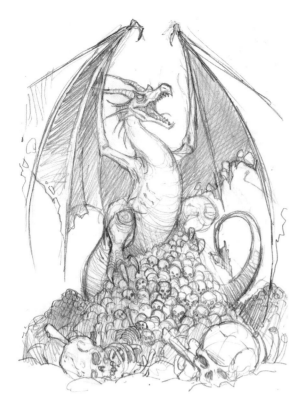

Figure 12

Figures 11–14 are the rough thumbnails and concepts explored in the thought process that helped me arrive at the final image. In most of the roughs (not all of them are featured here) the wings were used to draw the viewer in to the center of the image, where the action is taking place. The ever-reliable, tried-and-tested framing devices of a large sphere and a pillar of smoke were used to isolate the shape of the dragon and draw attention to the action.

Although I liked the close-up, intense image in Figure 11, its composition didn't leave space for much scenery. Since this book focuses not only on the figures but also the environments that complete the picture and provide mood and atmosphere, I felt that a wider shot was necessary to incorporate both a full-figure dragon and its setting.

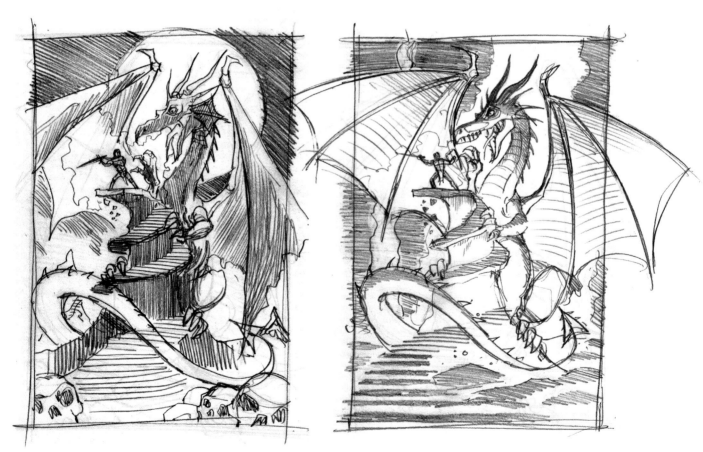

Figure 13

Figure 14

STEP 1

Start by plotting out the content of the layout. For the purposes of clarity I have adjusted the strength of the line work so that it prints clearly, but I recommend you keep the rough plotting light so that it can easily be corrected with an eraser and you can work over the top of it successfully. You will notice that all the elements are composed around a central vertical line. The dragon's head is at a very slight angle so the inside of its mouth will be visible. If it helps, think of the head as a tapered rectangle shape, roughly drawing the sides as I have done, and then build the features around it.

STEP 2

Add the limbs, tail and wings to the dragon. Wrapping the tail around the stone ruin enables the dragon to further dominate the scene, and the wings provide a framing device. Pay attention to the form of the feet and hands, as these can be difficult to perfect. If necessary, practice sketching them on a scrap of paper before adding them to the artwork.

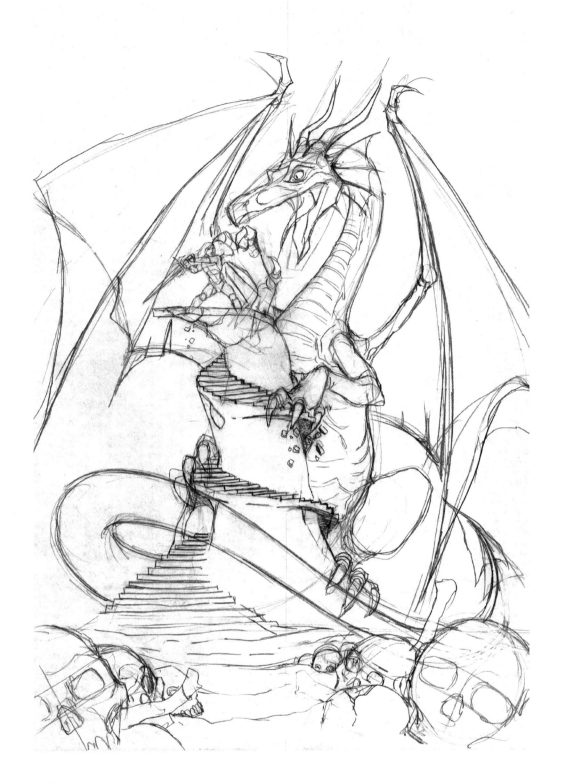

STEP 3

Begin to add more detail to the dragon and the ruin, taking time to plot carefully the steps winding around it. Notice that I have added other points of narrative interest, such as the dragon's claw demolishing a section of the steps, to suggest that this is a final battle, a point of no return for the warrior. You can also start to plot the foreground using a low point of perspective. The skulls in the foreground do not follow the perspective lines, as the ground is uneven and full of sunken areas. I chose to place skulls in the foreground to suggest that many had tried and failed to conquer the beast.

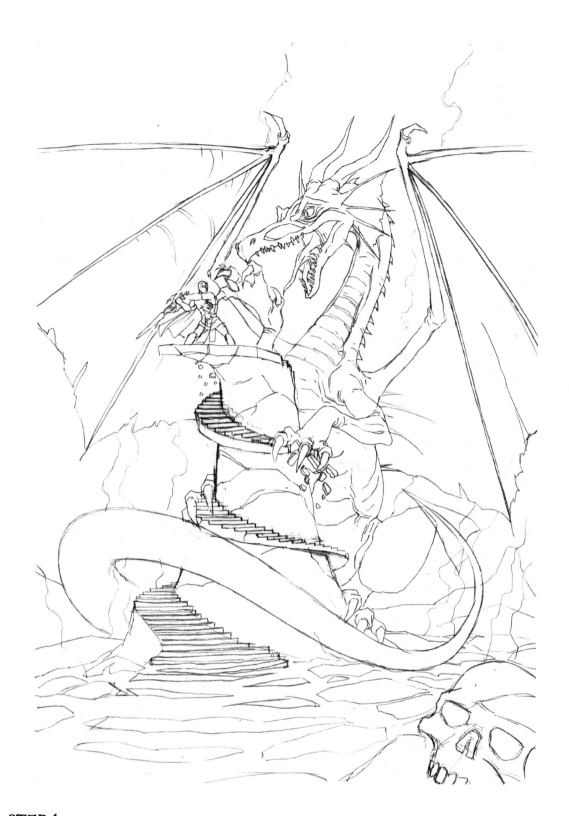

STEP 4

Take a look at the composition. Do the elements work well? What is the focus of the drawing? I decided that although the skulls were a nice feature, my eye was drawn too much to them and I wanted it to be focused on the main point of interest—the battle scene. I removed most of them, leaving one at the bottom right as a reminder of previous defeats. I decided to draw the ground as broken and floating on a bed of molten lava, to make the environment even more perilous. Notice that I have adjusted the angle of the steps at the base of the ruin. At this stage, if your drawing is looking a bit grubby, you might want to trace it onto a clean sheet of paper using a lightbox, if you have one.

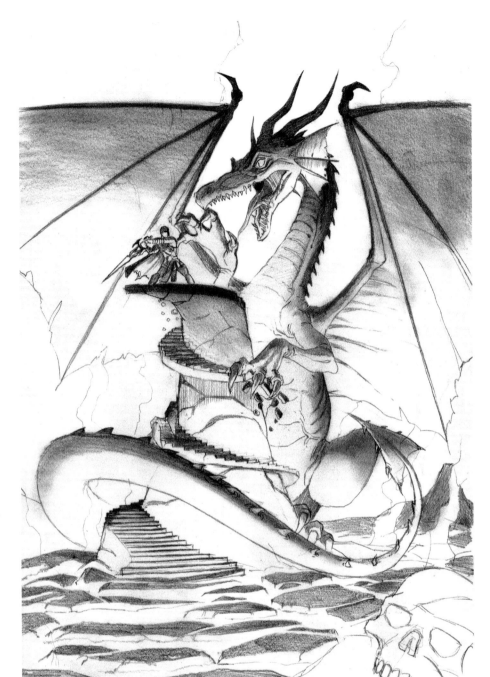

STEP 5

In order to begin shading the outline, you need to identify where the light source is coming from so that you can determine which areas are highlighted and which are in shadow. In this instance, since the ground is lava—a source of intense heat—it makes sense for the lighting to come from below, creating shadows to the higher outer areas of the dragon and the scenery. Begin to shade in these areas and identify the parts that will be darkest and will anchor the image (Figure 15).

Figure 15

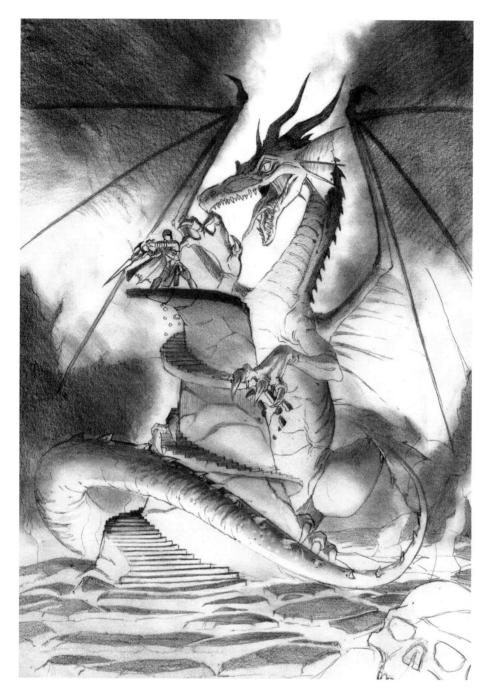

STEP 6

Once the darker areas have been identified, begin work on building up layers of tone over all areas of the drawing. This will act as a base layer upon which you can add layers of darker tone, more detail and textural interest.

Blend together the first layers of shading to meld the pencil strokes and create a smoother overall tone. I vary my tools for blending—I may use a blending stump for smaller areas and a sheet of tissue paper wrapped round my index finger for larger areas (Figure 16).

Figure 16

STEP 7

To create the textured effect on the dragon's wings, hold the pencil at a low angle, almost flat, and run it across the paper, using any texture within the paper's surface to add to the effect. Use this same technique on the dragon's skin, applying more pressure to create darker tones.

STEP 8

Once all the textures and tones have been applied, go over the drawing with an eraser to remove any unwanted pencil marks and shading where it interferes with the clarity of the line work.

STEP 9

I also use an eraser to create highlights, which help to lift the foreground from the rest of the background tone.

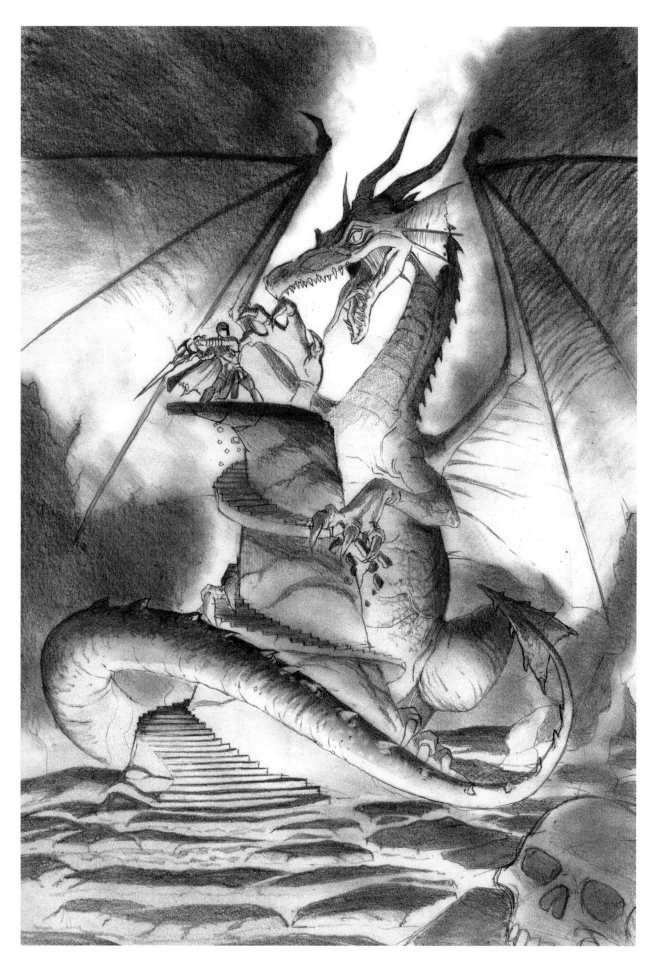

STEP 10

After creating highlights with an eraser, re-apply pencil to any of the line work that may accidentally have been erased or smudged. You need to create a defined outline that will make the dragon stand out. Use as sharp a point as you can for this. Some artists prefer to use a technical pencil for crisp line work, but a very sharp pencil will do just as well. Make sure that details such as the claws and teeth, which should look razor-sharp, are extremely crisply defined.

STEP 11

Use the flat edge of an eraser to add shafts of flickering light emanating from the molten lava below the dragon. The larger, flatter eraser won't totally erase the pencil work—instead it will make the shafts of light appear slightly translucent. Lastly, use a smaller eraser to create finer highlights and give the effect of flames. Sit back and assess the piece, making any last corrections or adjustments as required.

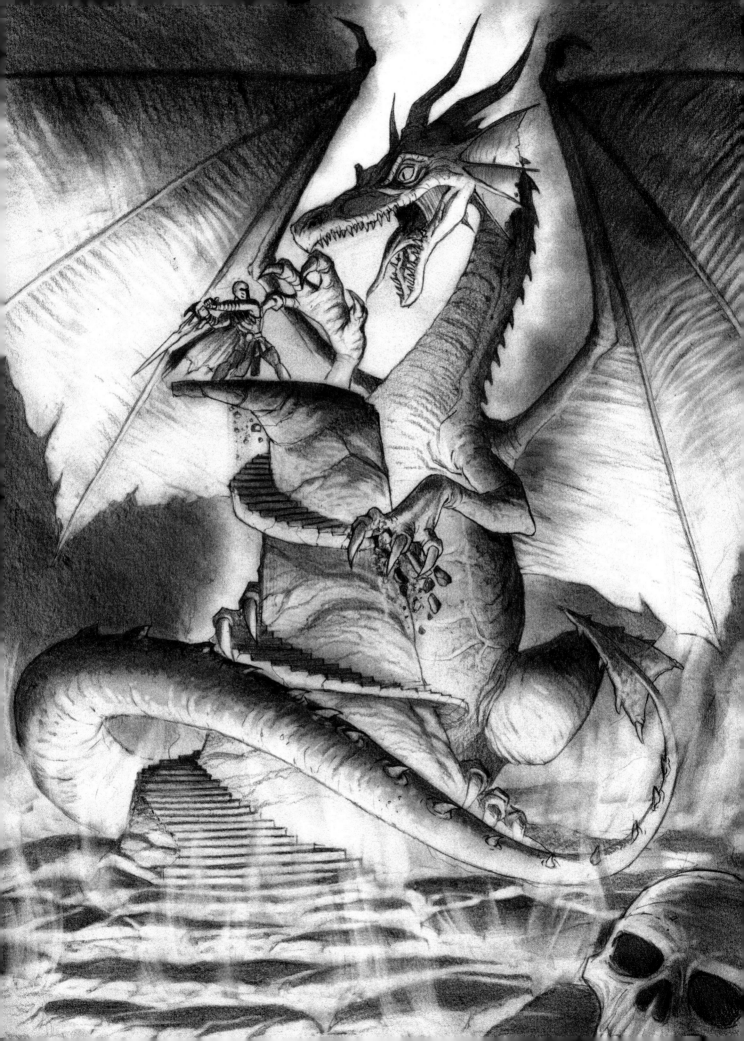

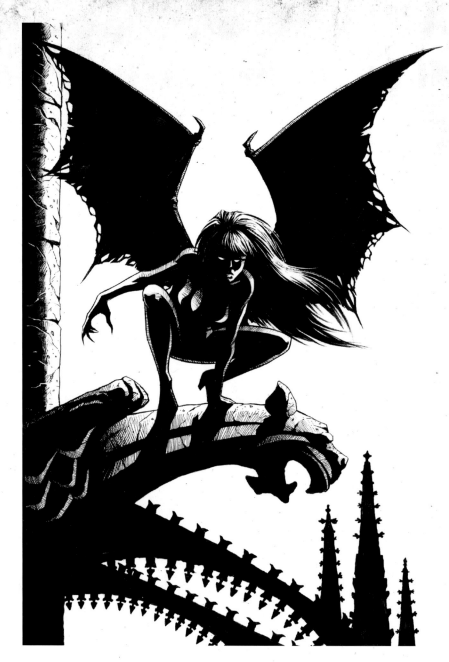

EXERCISE 2

CREATURE OF THE NIGHT

Since my teenage years, I have been a fan of the comic book character Vampirella, and, more recently, Selene, played by Kate Beckinsale in Len Wiseman's *Underworld* series of vampire movies. This relatively simple artwork is inspired by both those characters. You will be able to produce it as a pencil or an ink drawing.

Initially, I had an idea to produce a drawing greatly influenced by Vampirella (Figure 1), in which the character is perched on a gargoyle and framed by a Gothic arch opening. However, having produced the rough thumbnail sketch, I realized it was not the layout I wanted to draw. I therefore produced another quick thumbnail sketch that looked more like a demonic Batman character (Figure 2). As soon as I saw it, I knew there was something about it I liked. I then created a third thumbnail sketch, returning to a female figure and including more Gothic architecture (Figure 3).

What I liked about the third thumbnail sketch was that most elements were more or less depicted in silhouette. It pleased me that the figure could work as a silhouette, and details were left to the imagination of the viewer. Sometimes an image that requires viewer input can be more provocative than a more explicit image. The curves of the gargoyle and the flying buttress create a nice design, too.

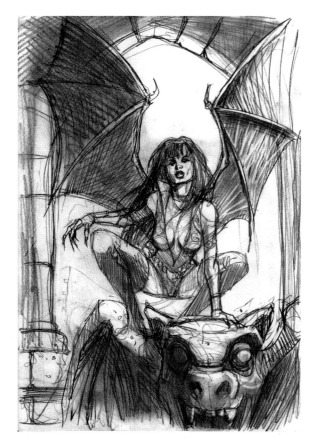

Figure 1

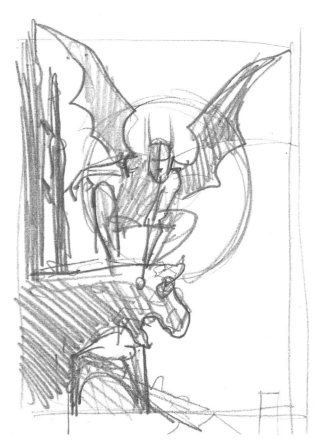

Figure 2

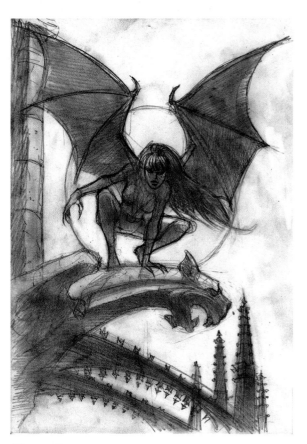

Figure 3

Since this image includes Gothic architecture, I thought it would be helpful to provide some images for reference. Almost any material you require for reference can be found on the internet, and it is well worth doing your own research so that you can create a better composition. Figure 5 shows an example of a flying buttress, a structural feature of many grand buildings and an aesthetically pleasing setting for a fantasy drawing. Some buttresses have ornamental stonework, as shown in Figures 4 and 5, which can be used to add texture and atmosphere to a drawing. Figure 6 is a pretty good reference image for the type of gargoyle depicted in the rough sketch, but there are hundreds of other examples available.

When I visit any towns or cities that have interesting architecture, I try to remember to take a camera and/or sketchbook with me in order to record any information that may be of interest at a later date. Figures 7–10 are examples of sketches from some of my days out. Figure 7 shows how crockets (hook-shaped decorative elements common in Gothic architecture) are used to decorate a spire. Figure 8 is a close-up drawing of how the detail would have looked before age and weathering took their toll, the results of which are shown in Figure 9. Figure 10 is a finial, a detail typically carved in stone and employed decoratively to emphasize the apex of a gable or other distinctive ornaments at the top, end or corner of a structure. Architectural finials were once believed to act as a deterrent to witches on broomsticks attempting to land on one's roof!

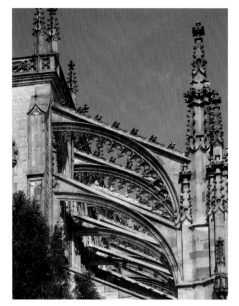

Figure 4

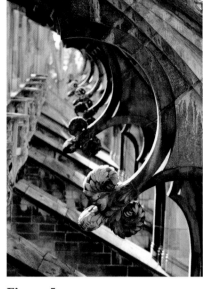

Figure 5

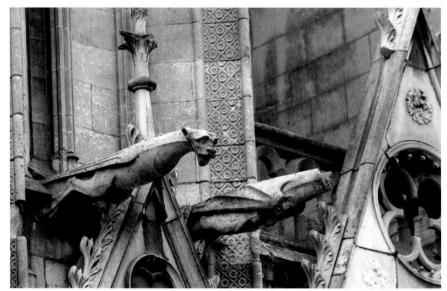

Figure 6

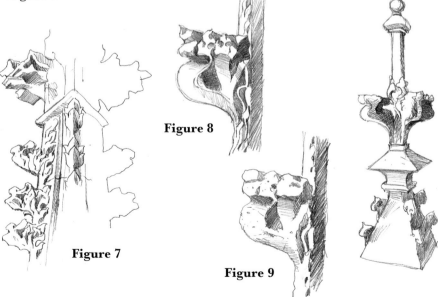

Figure 7

Figure 8

Figure 9

Figure 10

STEP 1

Start by loosely sketching out the composition on a large sheet of paper. Here, I started again and went back to basics, creating the figure using circles, ovals and cylinders and sectioning the face before fleshing out the construction shape. Using this method will help you to create a more balanced and accurate figure.

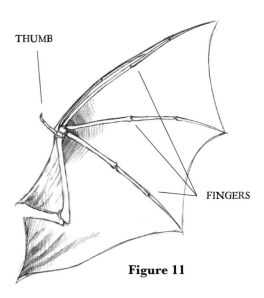

THUMB

FINGERS

Figure 11

Practice drawing the anatomical features on a separate piece of paper (Figure 11), so that you are familiar with them and can render them accurately in the finished piece. When drawing wings resembling those of a bat or dragon, try to keep in mind the structure of a wing and how it is held together—not dissimilar to a human arm and hand. The bat has an arm in two parts, with four fingers and a thumb. The digits are very long, however, and the skin that forms the wing is stretched across the arm and fingers. The bone structure of a bird's wing is also similar (except that it does not have four fingers), and the "arm" folds in the same way. Here, I decided not to draw the skin that covers the upper outer area of the arm on a bat's wing as I wanted to create a more angular shape around the head.

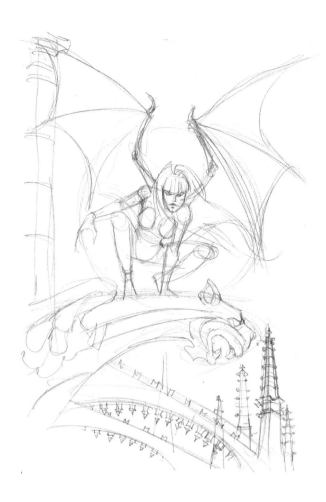

STEP 2

Draw in the outline of the surrounding building, referring to photos and the finished image for this project and making rough sketches on a separate piece of paper if necessary. It is a good idea to use vanishing points and guidelines so that the perspective is correct, especially when drawing buildings. I have not drawn in too much detail on the figure, gargoyle or the architecture, as they will mostly be solid black. I have sketched just enough information in order to plot the shapes as accurately as possible.

When drawing the decorative architectural details on the flying buttresses and the crockets on the spires, I went for irregular, inconsistent shapes. If you study the stonework of old buildings you will notice how age and the elements have worn away the shape of the stone, and I wanted to replicate this weathering.

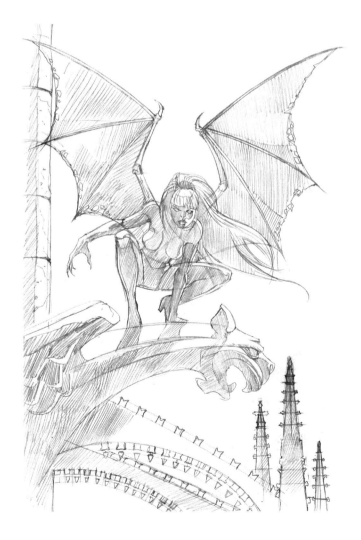

STEP 3

Now it is time to add highlights to the gargoyle and to the outer edges of the figure, to prevent these from looking flat. As I had decided to make this a black-and-white ink drawing, I chose not to include the full moon in the background, which was going to be used to frame the figure, and was no longer needed. Nor did I add any highlights to the architecture in the background, so I didn't shade those areas.

STEP 4

Once you are completely happy with the picture, it is time to ink it in, starting off by going over the outlines with ink. How I approach inking a drawing can vary each time. Sometimes I use a couple of brushes—one for fine detail and a larger one for filling in—or I may just use a Copic Multiliner brush pen as I can produce both fine work and broad strokes with the same pen. For this drawing I used a Faber-Castell Superfine pen to create an outline to ink.

STEP 5

Ink in the hair without producing an outline first, as this could make it look too mechanical; there should be some texture to the outer shape of the hair. I used a Copic Multiliner brush pen, which produces flowing, natural-looking lines.

STEP 6

Use a brush pen rather than a superfine pen to ink in the architectural details, as these shouldn't look too precise and sharp.

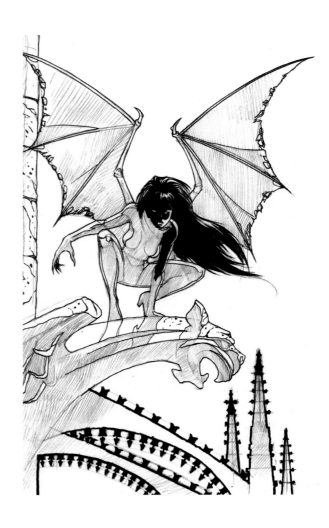

STEP 7

Fill in the outlines in solid black, where required, using a brush and ink. Take care to leave highlighted areas white and do not smudge the ink. Leave the ink to dry thoroughly.

STEP 8

You can now start adding textures and tone. I applied ink to the stone wall using a flat brush. By loading the brush sparingly, the ink thins out as the brush travels across the paper, creating a dry-brush effect (Figure 12). The texture of the paper also adds to the effect, depending on its coarseness. Add in any hatching to areas that require shading. Continue to use a Faber-Castell Superfine pen to create the hatching on the gargoyle and the wings.

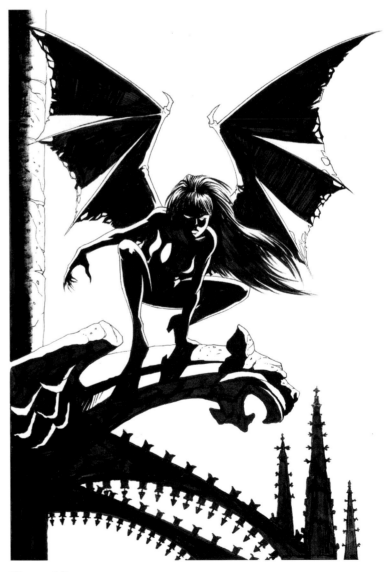

Figure 12

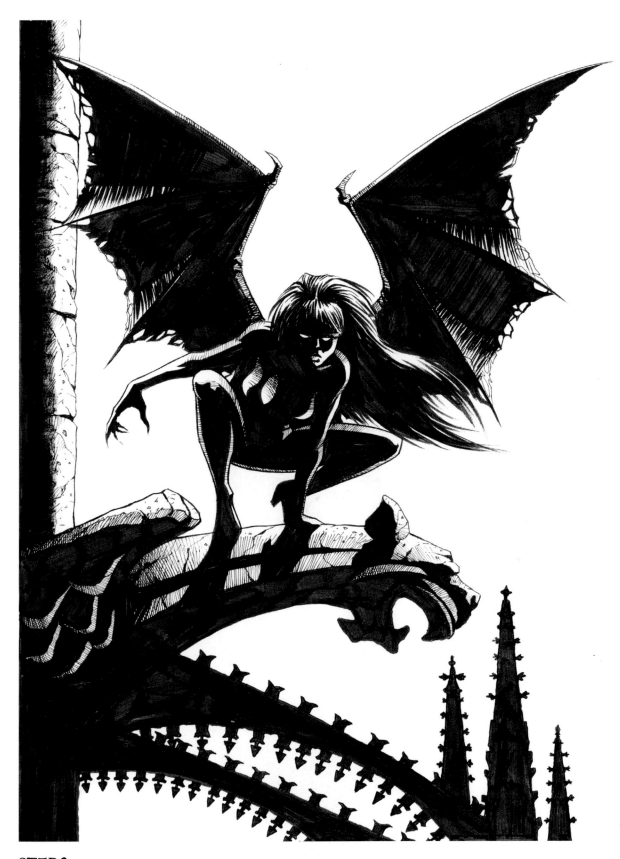

STEP 9

Now it is time to sit back and evaluate the drawing. Does the foreground stand out adequately against the background, or is more work required? In this case, I was satisfied that the details and texture on the gargoyle successfully create the illusion of perspective, with the gargoyle and figure appearing to be some distance in front of the flying buttress and spires in the background.

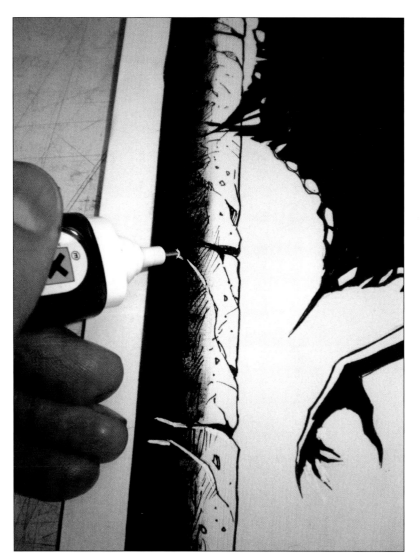

STEP 10

Once you are satisfied with the textural aspects of the drawing, assess whether you could apply more highlights to add extra interest. Using a Pentel correction pen, I sparingly drew in some fine cracks and specks on the stonework. Details such as these can also be created using opaque white correction fluid and a fine brush or a sharp white crayon pencil. Use whichever medium you feel most comfortable with.

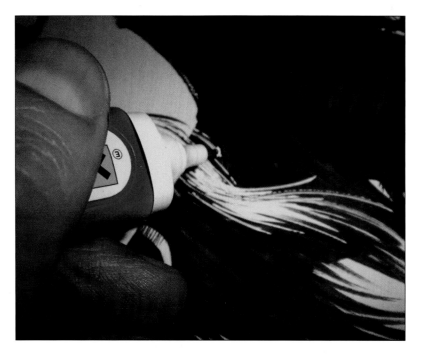

STEP 11

Add highlights to other areas, such as the hair (for which I also used the Pentel correction pen). As mentioned above, the same effect can be established using opaque white correction fluid and a brush or a white crayon pencil.

STEP 12

Assess the image again. Are there any elements that need changing? In this instance, I chose to ink over the detail on the inside of the wing (see facing page), but decisions such as these are largely a matter of preference. If you feel your drawing will look better with the detail remaining, then keep it; do whatever you feel gives the best result.

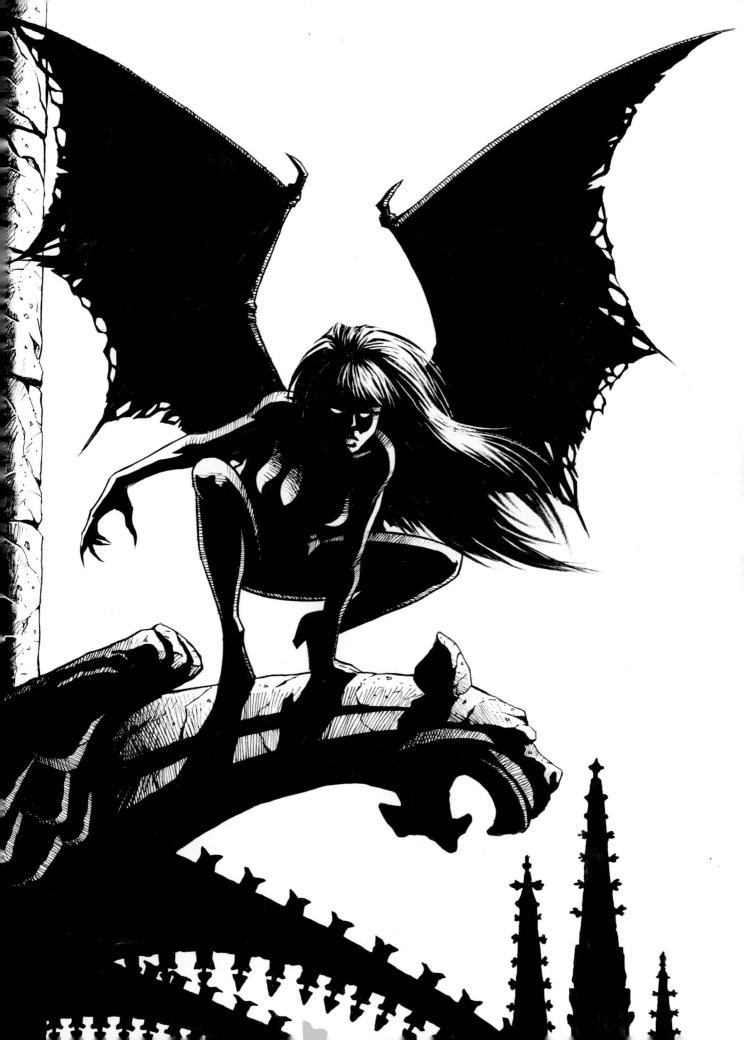

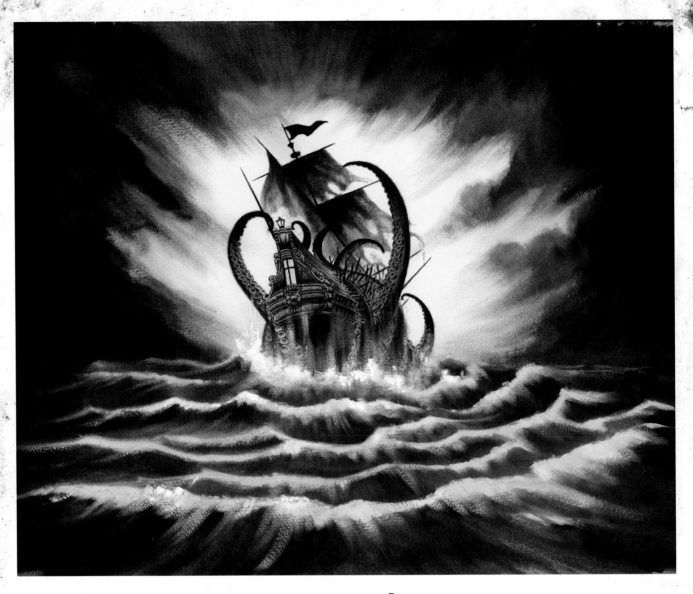

THE KRAKEN

I have long enjoyed watching movies that feature giant, tentacled marine creatures, such as *20,000 Leagues Under the Sea*, *It Came From Beneath the Sea* and *Clash of the Titans*. I am an unashamed fan of all Walt Disney's *Pirates of the Caribbean* movies, but my favorite is *Pirates of the Caribbean: Dead Man's Chest*, which features the mighty sea monster Kraken. The above painting was inspired by a scene in which the Kraken takes down the ship the "Black Pearl."

The painting was produced using Winsor & Newton gouache on cold-pressed 300gsm Arches Aquarelle Watercolor Paper.

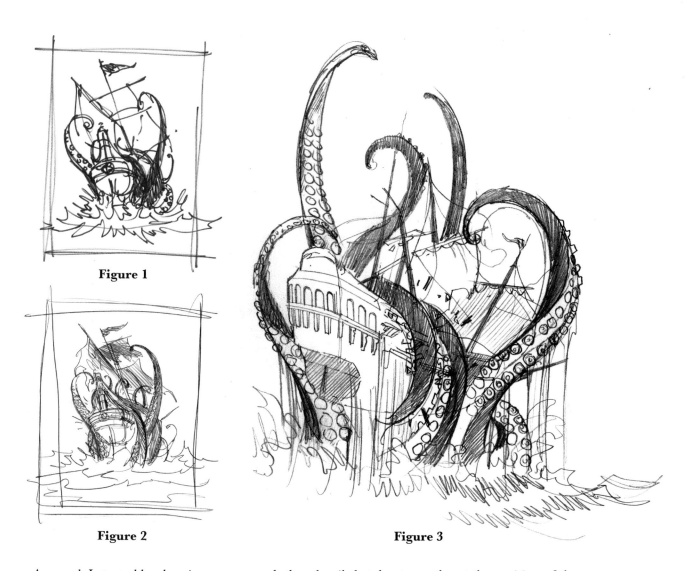

Figure 1

Figure 2

Figure 3

As usual, I started by drawing some rough thumbnail sketches to work out the position of the boat and how the tentacles should wrap around it. These early ideas are shown in Figures 1–3, and you can see the progression of the level of detail drawn and the different angles I tried out. I decided to use the set-up shown in Figure 2 and went on to color the image using markers (Figures 4 and 5) in order to establish the color scheme before I started painting.

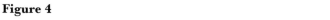

Figure 4

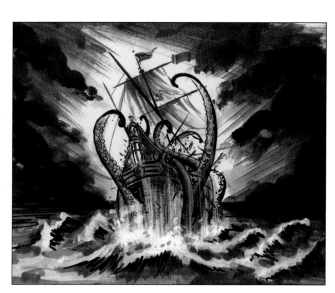

Figure 5

Before drawing the ship in the grip of the Kraken, I produced a quick sketch (Figure 6) to work out the shape of the ship accurately, ensuring that all the basic components were present and in the correct place. Sourcing reference material for unfamiliar subjects such as ships is always a good idea, particularly when you want them to look of a period, in which case the shape and detailing are especially important.

Figure 6

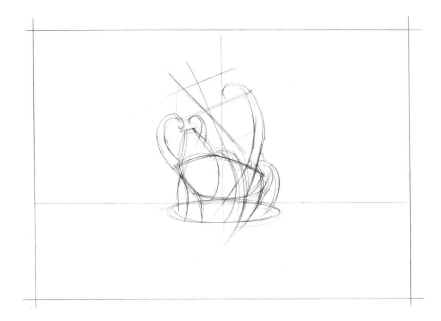

STEP 1

When you are going to paint on watercolor paper it is worth drawing the image first on standard paper (I used A3-size paper) and then lightly tracing the working drawing onto the watercolor paper. This prevents the watercolor paper becoming marked with sketching that then need to be erased, and makes for a much better end result.

Start by marking the horizon and plotting the image around a center line. At this stage I was still undecided about whether to tilt the ship up or down. In the end I decided to show the ship being crushed by the Kraken's tentacles, which means that it would appear to be angled up and leaning to the left. I also drew in the position and action of the tentacles.

STEP 2

Add more details to the ship, trying to make them as accurate as possible. Roughly draw in the clouds and waves, arranging them so that they lead the eye toward the center of the painting, where the action is taking place.

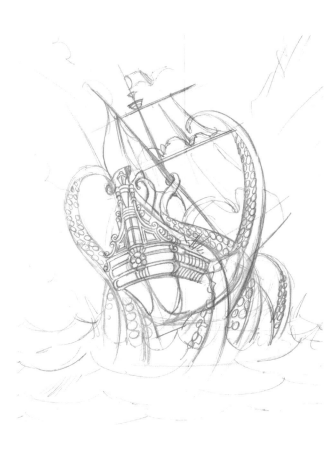

STEP 3

Refine the decorative detail on the ship's stern and on the tentacles. This ship is the result of a combination of reference sources, including some old books about sailing ships I have collected. However, by the time I finished it I realized the artwork was as much a homage to Frank Frazetta's painting "The Galleon" as anything else. Discoveries like this one are part of the fun of fantasy art.

STEP 4

Shade the clouds and the rear of the ship to establish the areas that will have the darkest tones. The waves here are exaggerated, but when I drew smaller ones the image looked rather tame, so I went for bigger, more dramatic waves to create the appearance of a great disturbance in the sea.

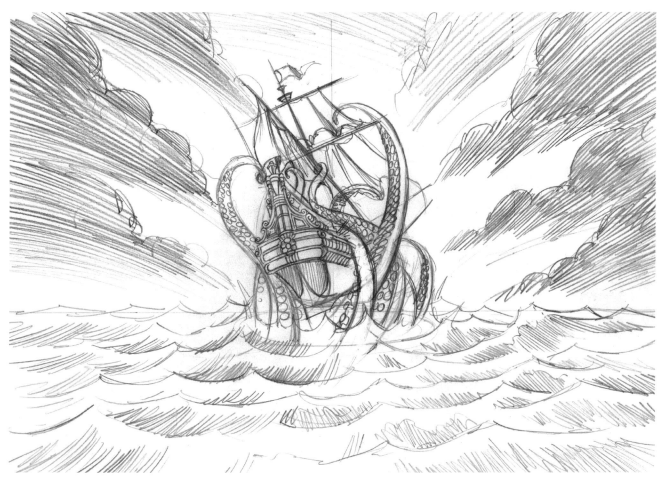

Once you are happy with the working drawing, trace it onto a sheet of watercolor paper using a lightbox. It is a good idea to stretch the watercolor paper first by laying it flat in a bath or sink of water and soaking it for 10–15 minutes, insuring it is completely saturated. Lift it out and allow the excess water to drip off, then tape it flat to a clean, level board or desk with brown paper tape and leave to dry. By saturating and then drying the paper before you add watercolors, you avoid running the risk of the paper buckling when you use numerous washes of paint.

When the paper is ready, angle the board or desk so that when you apply washes of color the paint will flow downward. I use an adjustable drawing desk, but if you do not own one you could try using more affordable portable easels or desk easels, which are available at most arts and craft stores.

Once the paper is prepared and ready, assemble the paints you need to complete the art. I have kept to a simple palette, using the following tones of blue, yellow and green: Sky Blue, Cobalt Blue, Winsor Blue, Prussian Blue, Cadmium Yellow, Yellow Ochre, Raw Sienna, Olive Green, Sepia and Jet Black.

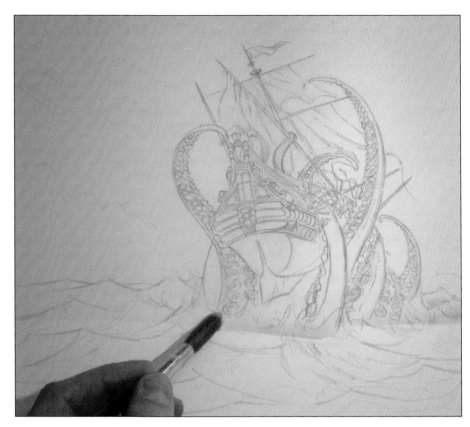

STEP 5
Apply a first wash of very watered down Cadmium Yellow Pale. I used a size 12 Winsor & Newton sable brush.

STEP 6
While the yellow wash is still wet, apply a wash of Sky Blue, allowing the blue to run into the yellow to create a soft blending effect between the colors.

STEP 7

Build up the strength of color in the clouds. I used Winsor Blue and Prussian Blue mixed with a very small amount of Jet Black. The Winsor Blue was applied as a concentrated wash, while the consistency of the Prussian Blue mixed with Jet Black was slightly thicker than a wash, but still wet enough to allow color spread.

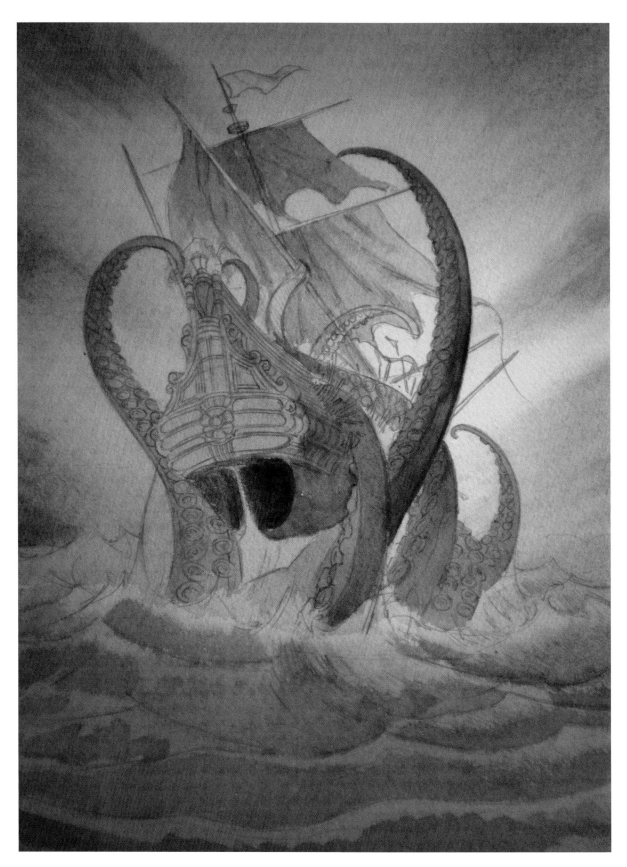

STEP 8

Allow the first washes to dry, then apply layers of Cadmium Yellow, Yellow Ochre and Raw Sienna to the body of the ship. Build up the color of the tentacles using washes of Olive Green and Sepia, both with just a hint of Jet Black. Add washes of Olive Green and Sepia to the ship's sails.

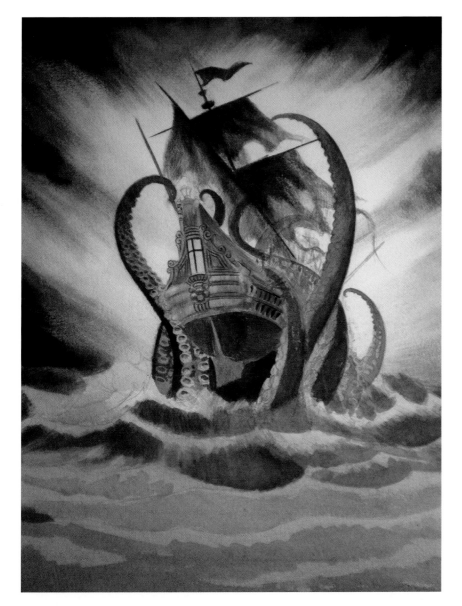

Figure 7

STEP 9

Apply thicker, less liquid layers of Prussian Blue and Jet Black to the clouds, using a dry brush effect to break up the color and create texture (Figure 7). All brush strokes should be directed towards the center of the image, so that they surround the action. I used a size 8 flat shader brush.

STEP 11

Add thicker layers of Olive Green mixed with Sepia and Jet Black to build up the solid, darker tones of the tentacles to give them more presence. I applied darker mixes to the very top and around the inside and outer edges of the suckers to create a sense of shape and depth. I used a size 8 flat shader and a size 3 sable brush for the finer work on the tentacles.

STEP 10

Add thicker washes of Olive Green mixed with a tiny amount of Jet Black to the sails, applying darker tones to the top of the sails.

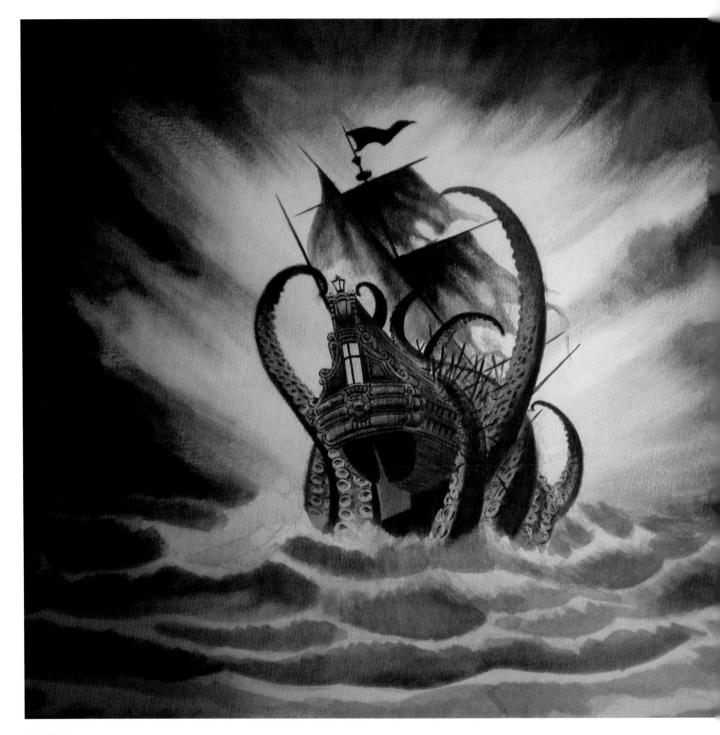

STEP 12

Using a size 8 flat shader and a size 1 flat shader, apply more concentrated layers of Cobalt Blue and Prussian Blue, both mixed with a little Jet Black, to the waves. You are aiming to add just enough black paint to darken each tone of blue. The waves should become progressively darker toward the outer areas of the painting.

With a size 8 flat shader and thin pastes of Olive Green and Sepia, create a dry brush effect on the stern to give some texture. Use darker tones of Sepia and Jet Black to highlight the detail on the stern, rudder and underside of the ship.

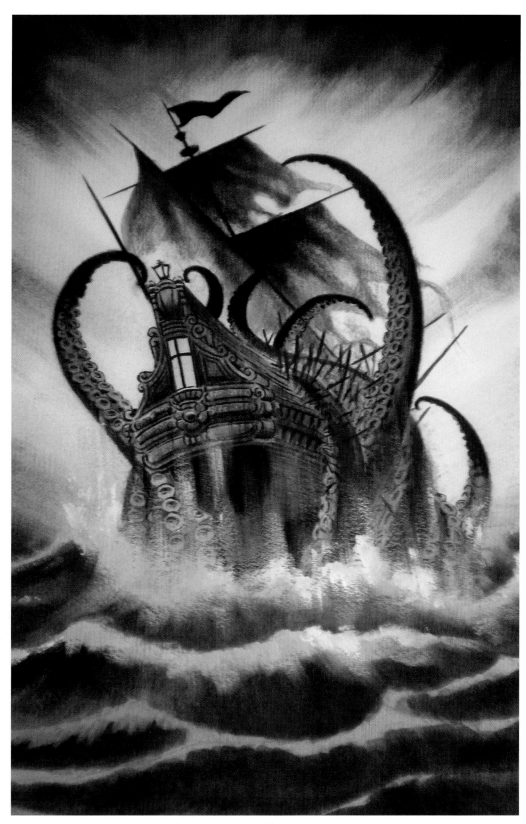

STEP 13

Using undiluted Permanent White, apply a dry brush effect to the surf of the waves and the base of the ship to create the illusion that the ship is being lifted out of the sea.

STEP 14

For the final touches, use a size 1 brush to apply Jet Black to the sails, tentacles and finer details of the ship to give them more strength. Use undiluted Permanent White and a fine brush to highlight details on the stern and the broken timbers.

STEP 15

Apply one last coat of black to the clouds and parts of the waves to give them more strength. This creates a dark, framing effect, drawing the eye to the center of the image.

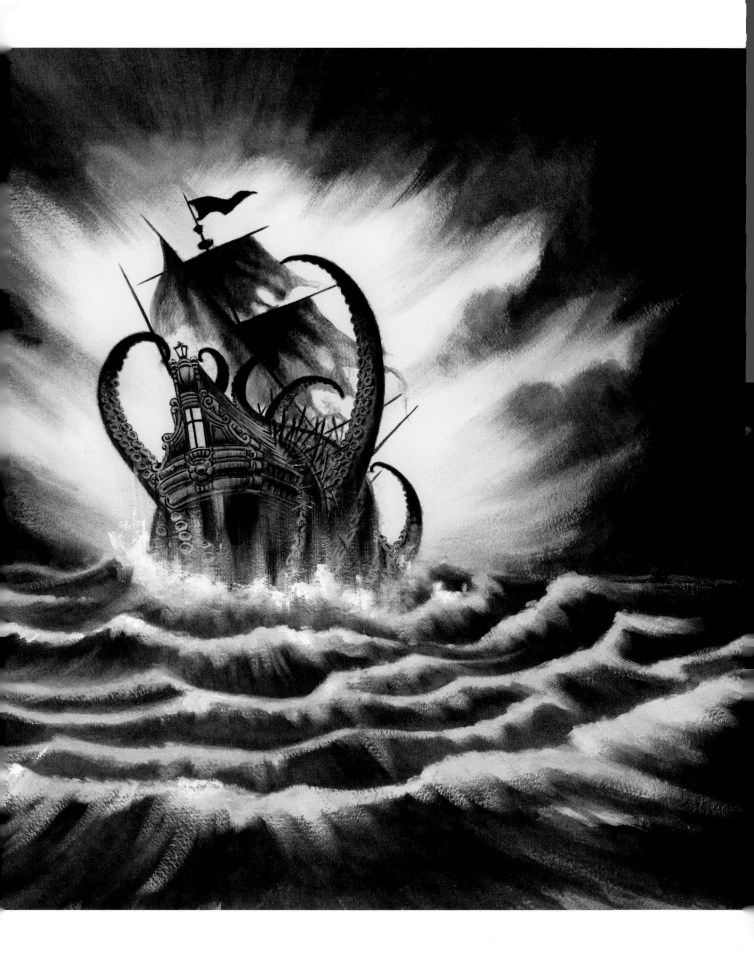

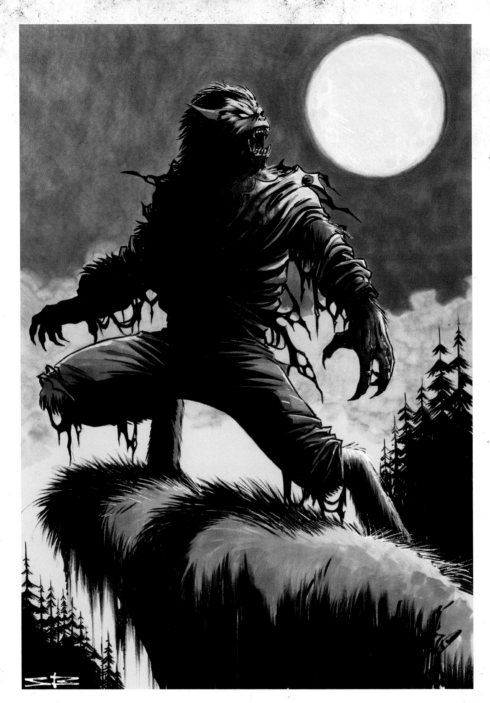

WEREWOLF

The werewolf reminds us of primal instincts within us all. It is a classic subject for lovers of horror films and fantasy art and really good fun to draw. I am a big fan of the 1941 Universal Pictures horror movie *The Wolf Man*, starring Lon Chaney, Jr. in the title role, but the above image is more influenced by the 2010 remake, starring Benicio Del Toro, and by *An American Werewolf in London* (1981) and *The Howling* (1981). This picture demonstrates how effective a simple layout and the application of color and lighting with just a handful of markers can be.

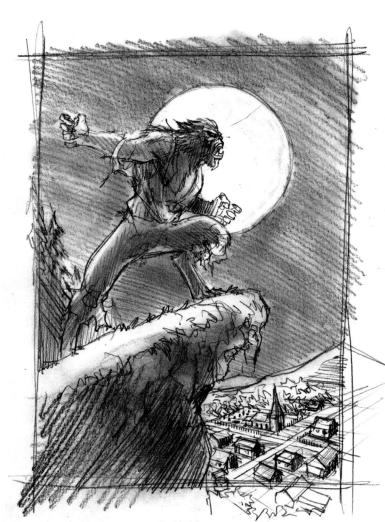

I started by sketching a few scenarios in order to work out the setting and stance of the character. My first idea was to have the werewolf howling on a clifftop above a small village (Figure 1), to imply that this was where the beast would find its next victims. However, much as I liked this idea, I felt that there wasn't sufficient focus on the beast itself, so I tried another approach and came up with Figure 2. This way, by making the werewolf larger, I could include more detail (Figure 3).

Figure 1

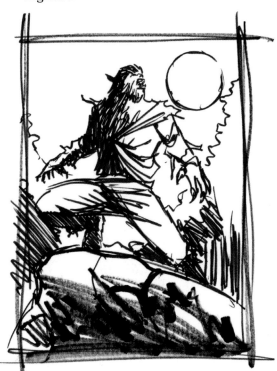

Figure 2

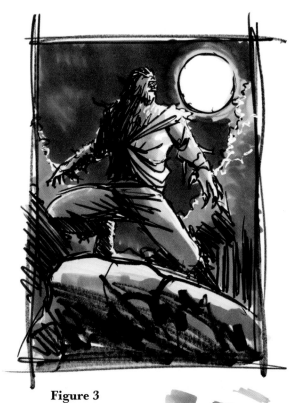

Figure 3

Exercise 4 WEREWOLF ◦⚬◦ **59**

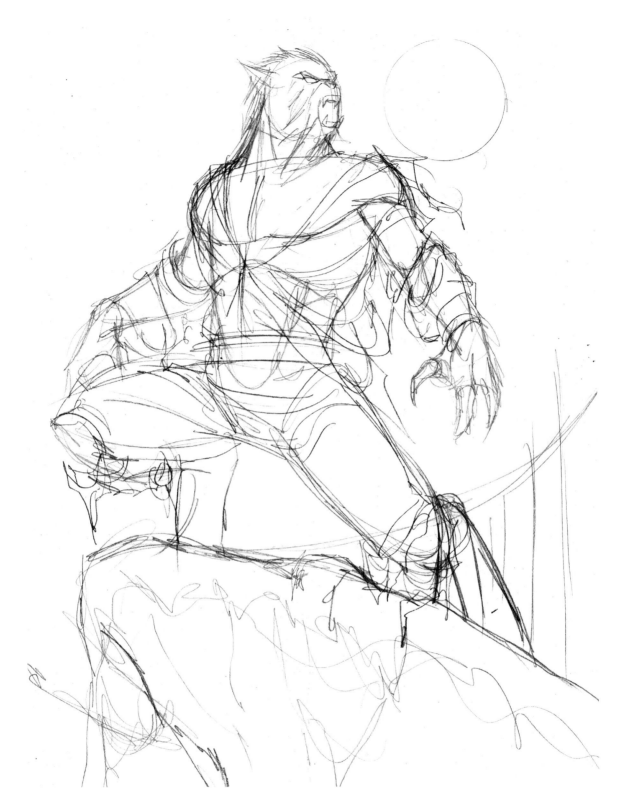

STEP I

With the rough layout planned, you can begin to plot the figure and the surrounding elements using construction shapes, line figures or loose shapes, as I have done. I decided to reduce the amount of trees in the background so that they did not interfere with the figure. I also refined the shape of the grassy overhang (this could be a cliff top, but I have deliberately made its appearance vague since it is merely a device upon which to perch the figure), so that I could add a small group of trees, at the bottom left, to suggest a sense of height. I also began to draw the details on the werewolf's face and plot how its clothing would hang.

Figure 4

Figure 5

Figure 6

STEP 2

In order to get the face and head shape right, it is worth practicing on a separate piece of paper. Approach drawing these elements in the same way as you would a human head, using the construction shapes shown as a guide (Figures 4 and 5). The main difference between the human and the werewolf face is that the werewolf's mouth and nose are positioned on a snout-like protuberance, a bit like a cat. The nose should be fairly flat, almost pug-like, but positioned high on the face. The teeth are enlarged, so the mouth should be bigger and wider than a human's to accommodate them. The ears are wolf-like and placed much higher on the head than a human's (Figure 6).

STEP 3

Try sketching the hands on a separate piece of paper too, adopting the same construction shapes as for human hands (Figures 7–10). The only main difference between them is that the werewolf is traditionally depicted with huge, sharp claws and thicker, heavier-built hands and fingers. It is important to instill some of the character into the position of the hands to make them appear dramatic and aggressive.

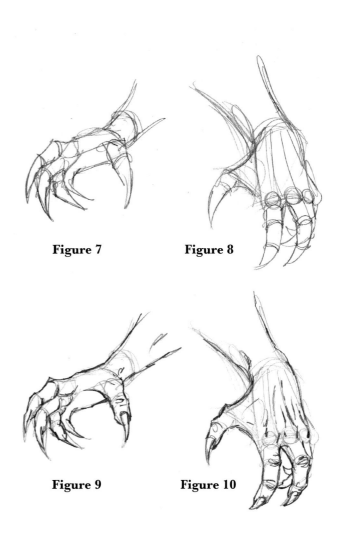

Figure 7 **Figure 8**

Figure 9 **Figure 10**

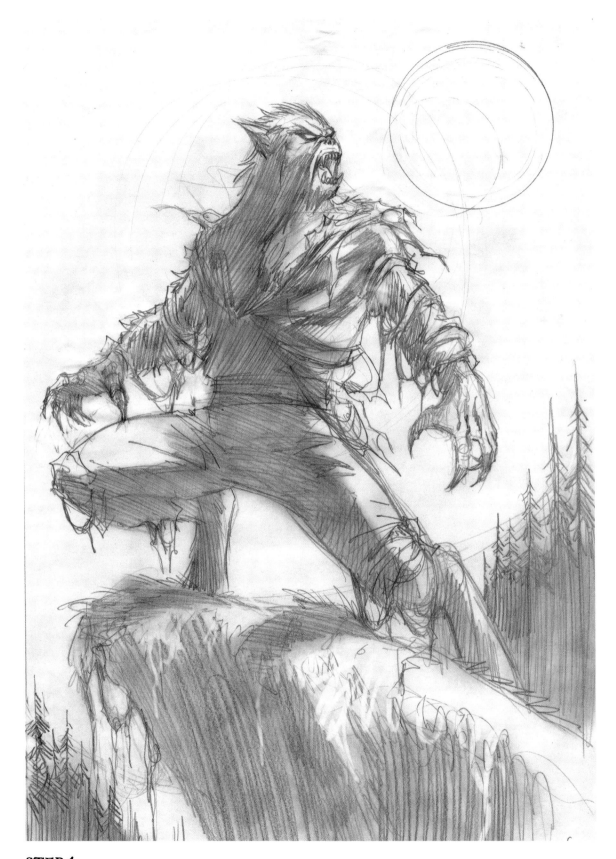

STEP 4

Once you have drawn the head, face and hands and are satisfied with them, add the clothing. I have purposely made it so torn and tattered that it is impossible to get an impression of period. The position of the light source, the full moon, creates heavy shadows that also contribute to the vagueness of the clothing's appearance.

STEP 5

Trace the working drawing onto a piece of pale blue A3 paper using a lightbox. If you do not have a lightbox, you can do an image transfer instead. Rub a soft lead pencil across the back of the working drawing, completely covering the piece of paper. Tape the drawing to the A3 paper so that the covered side is securely positioned face down on the clean sheet and the working drawing is face up. Firmly trace over the working drawing with a biro or hard lead pencil. This will transfer the lead pencil on the underside of the drawing on to the clean sheet as an outline. Whichever method you use, you are aiming to create a clean outline on the blue piece of paper (Figure 11).

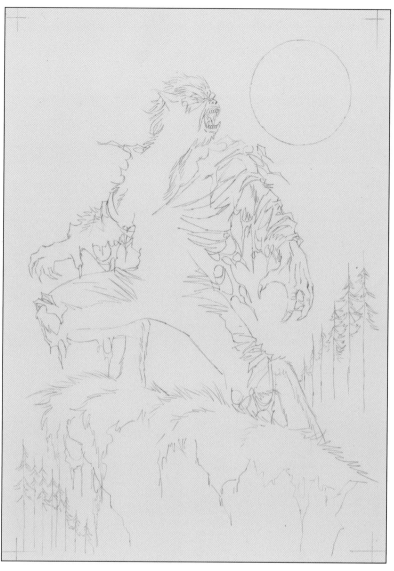

Figure 11

STEP 6

Using a Copic Multiliner brush pen, begin inking the drawing. This is a very easy inking job as it is mostly solid. Try to use the versatility of the brush nib to create a variety of line thicknesses so that the drawing does not look too technical and rigid.

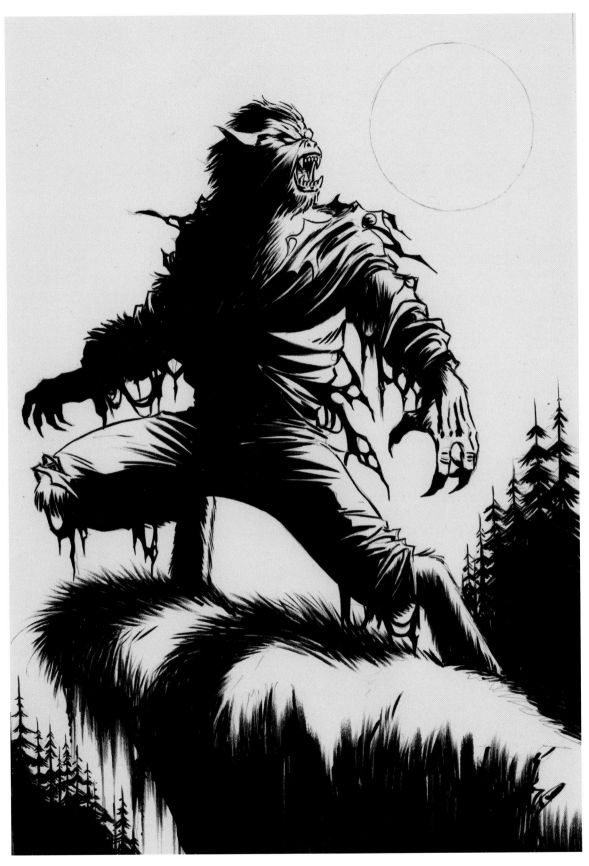

Here you can see the final inked drawing. If you had drawn this on white paper, you would have an exciting black-and-white drawing of a werewolf. But since this piece has been created on colored paper, you can create more atmosphere using five Copic markers and a Pentel correction pen, as I will show you in the next few pages.

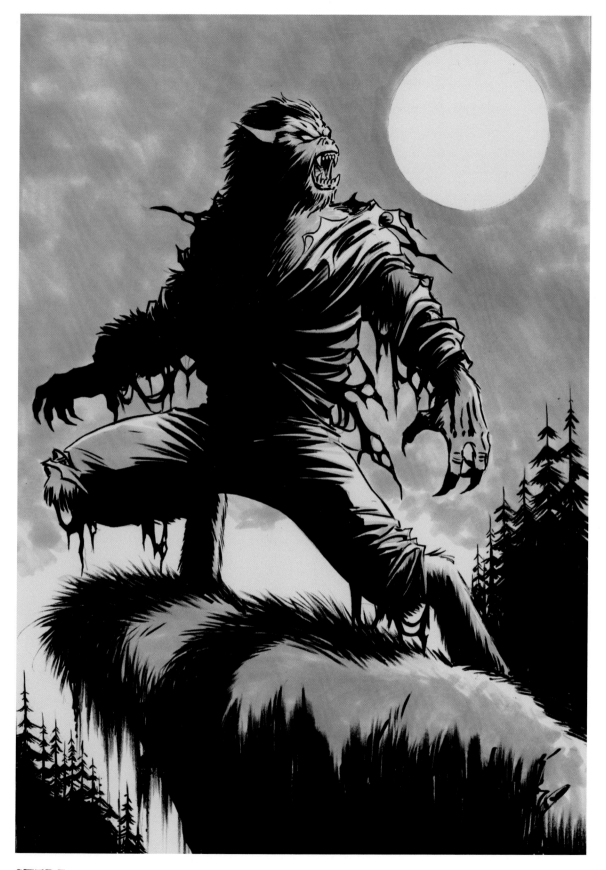

STEP 7

Use an Ice Blue (Copic B12) marker to create the base layer for the clouds and grass. I also used this marker to make a base layer for the darker tones of color on the clothing and fur.

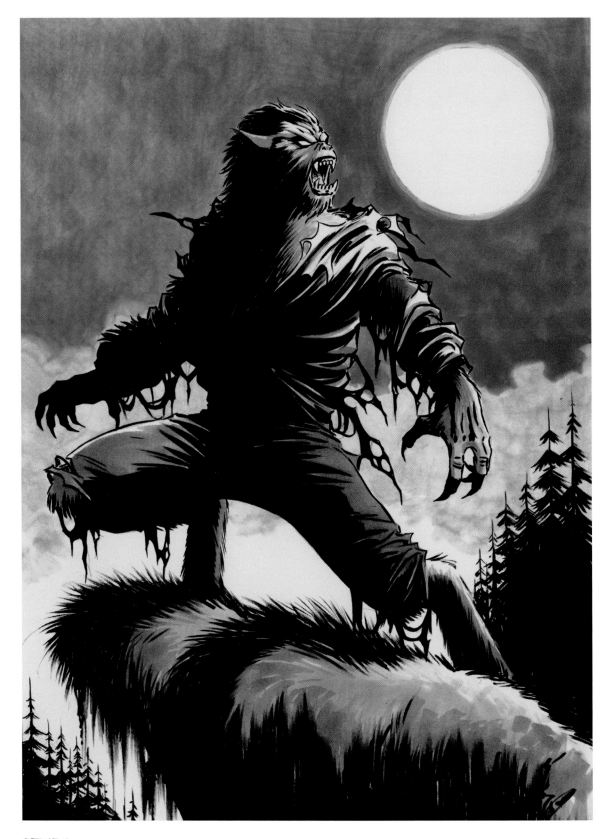

STEP 8

Create the darker tones of the sky with a Phthalo Blue (Copic B23) marker. This is not a particularly dark marker, but, layered over the Ice Blue, it creates the right shade. I also applied it to the grass, clothing and hair to build up the color tones.

Apply Warm Grey 2 (Copic WG2) to the fur and clothing, leaving highlights on the areas nearest the source of light (the moon). Warm greys are very useful for building up tone and texture.

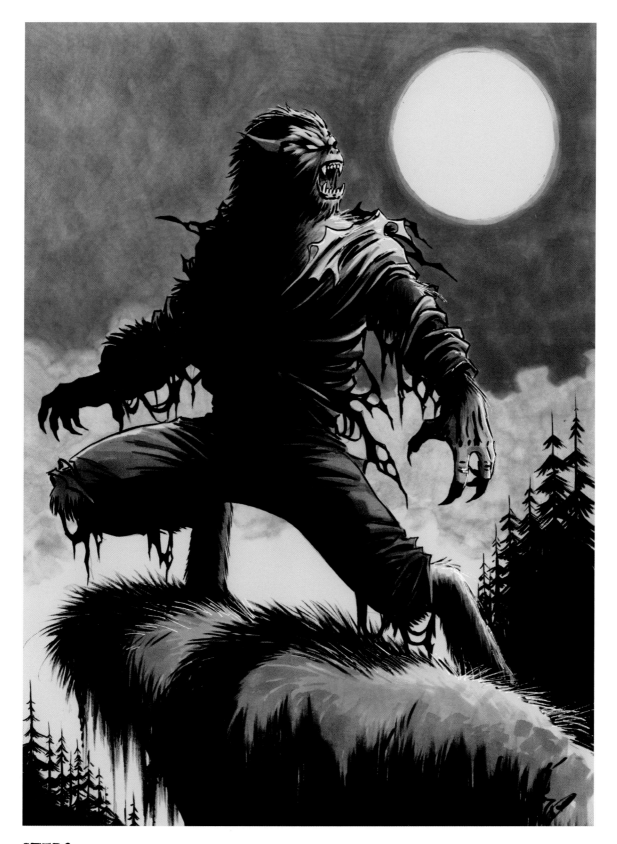

STEP 9

Apply Warm Grey 5 (Copic WG5) to blend the lighter tones and the solid blacks, particularly in the creases of the clothes and the areas of the fur nearest the solid black.

Use a Pentel correction pen to create white highlights around the outline of the figure and on random blades of grass. White gouache or Permanent White and a fine brush would create the same effect.

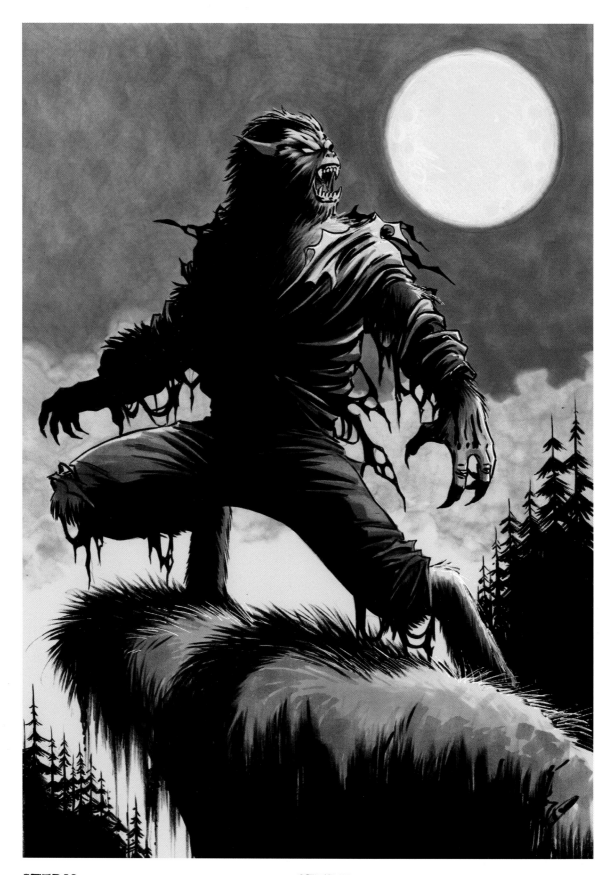

STEP 10

Use a white crayon
pencil to add soft
detail to the moon.

STEP 11

For the final touch, use a vermillion red (Copic
R08) marker to draw the blood on the mouth,
hand and clothing. Once layered over the darker
tones, the red ink creates a blood-like effect.

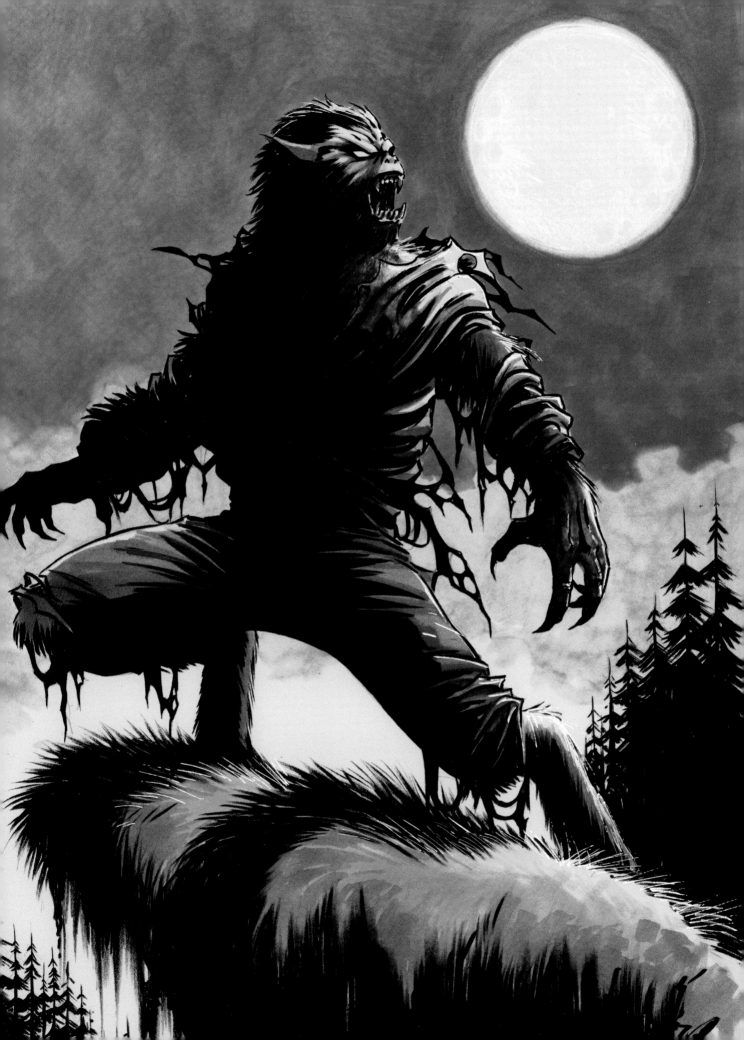

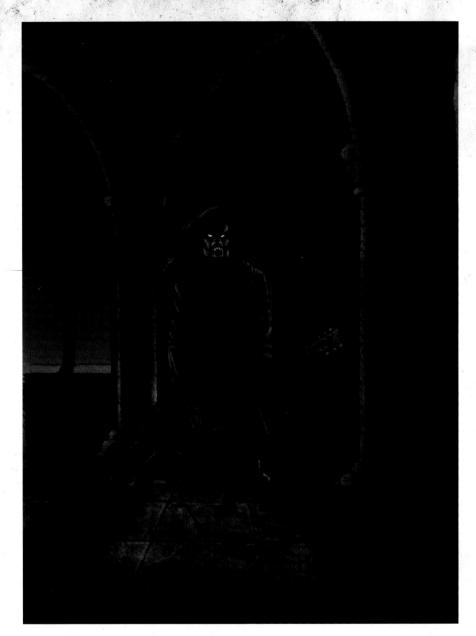

EXERCISE 5

— ◦•❧◦• —

ROCK'N'ROLL VAMPIRE

— ◦•❧◦• —

This drawing was inspired by two movies: Robert Rodriguez's *From Dusk Till Dawn* and Alex Proyas's *The Crow*. The images of undead rock musicians that feature in both have stuck with me over the years. This artwork was produced on 300gsm cartridge paper, using a combination of a Palomino Blackwing 602 pencil and a HB Staedtler pencil, then colored in Photoshop. It can also be produced as a monochrome pencil or ink drawing.

Figure 1

Figure 2

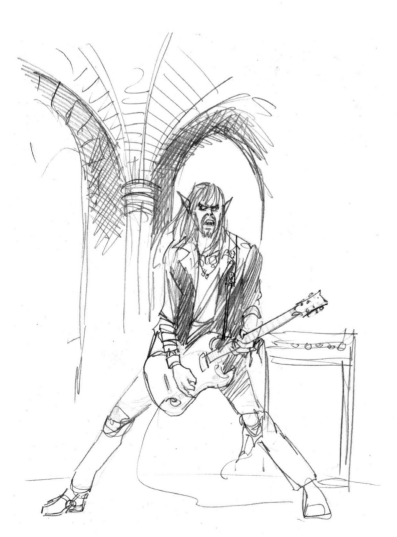

I began by producing some rough sketches of rock/metal guitarists (Figures 1 and 2). Initially the character I envisaged was based on Norwegian black metal guitarists with a demonic twist. I knew what setting I wanted, but wasn't sure of the pose. These sketches helped me see what did and didn't work. At the end of the process I decided that, although I really liked them, these drawings were moving away from my original idea, so I filed them away for use on another piece and started again.

This time I decided to go for more of a 1980s goth/punk feel, playing down the drama of the guitar shapes and making the instrument more low-key (Figure 3). Although I really like over-the-top, dramatic, in-your-face visuals, I also like more subtle imagery where the lighting and space set the tone as much as the figure.

Figure 3

STEP 1

Begin to plot the drawing using the vaulting and Gothic window in the background to frame the figure. In order to get the detail correct for a more realistic setting, it is important to source some reference materials, either by sitting and producing rough sketches in a small pocket-sized sketchbook (Figure 4) or by taking or researching photos (Figures 5 and 6). Keep this reference material in folders, both real and virtual, and over time you will build up an archive of invaluable information and inspiration that can be accessed quickly and easily.

Figure 4

Figure 5

Figure 6

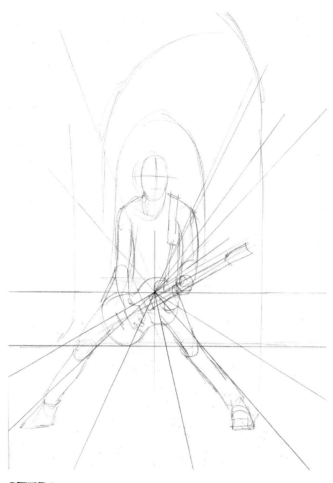

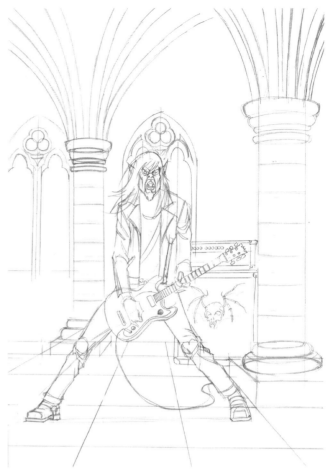

STEP 2

To plot the layout correctly, take time to draw some perspective lines (see page 17), which will enable you to gauge the position of the pillars and the size and angles of the flagstones on the floor.

STEP 3

Referring to the photos of Gothic architecture, begin to apply details to the pillars and vaulting. Since this will be a dark environment, you need only be concerned with the basic structural details. Do some research and choose equipment you like the look of, then use it to help you draw the guitar and amplifier. Having spent a lot of time attending rock concerts, I am very familiar with sound equipment as well as guitars. I was going to model the guitar on a Fender Stratocaster, but in the end I based it on a Mosrite guitar, simply because the shape appealed to me at the time. It could also easily have been a flying V-shaped Ibanez guitar. The amp is based on a Marshall amplifier, and the skull and crossbones image on the front is a nod to Gothic rock band Avenged Sevenfold.

STEP 4

Once the working drawing is complete, trace it onto a clean sheet of cartridge paper using a lightbox.

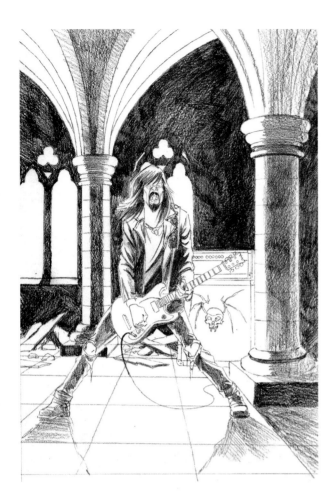

STEP 5

Begin to establish the darker, blacker areas using a pencil (I used a Palamino Blackwing 602), applying heavier pencil work in the background and lighter tones to the pillar in the foreground.

STEP 6

Blend the pencil work to a smoother finish using a blending stump rather than a piece of tissue, so that you can be really accurate.

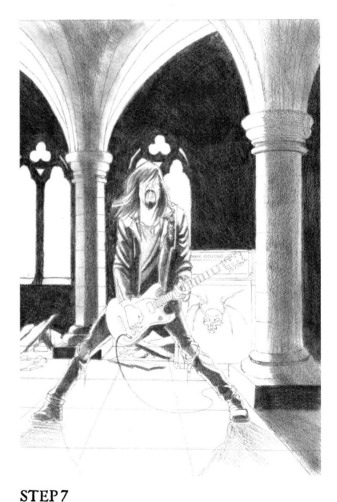

STEP 7

Using a Staedtler HB pencil, apply some mid-range tones to the vaulting and pillars. Pay attention to where the light source is coming from and position the highlights appropriately.

STEP 8

Using a sharp Staedtler HB pencil, add some detail to the lighter areas of stonework that will be more visible and add shading to the underside of the stonework. Even though the coloring and lighting will obscure most of the details, they will add texture.

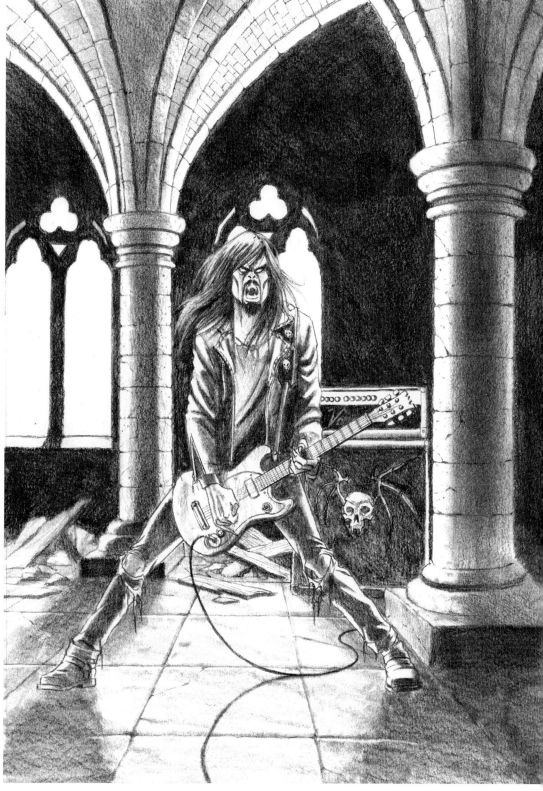

STEP 9

Still using a Staedtler HB pencil, apply lighter tones and texture to the flooring by lightly running the flat end of the lead across the surface of the paper.

STEP 10

Again using a sharp HB pencil, tighten up the finer details of the figure, paying special attention to the hair and face. Little details such as the holes in the T-shirt and the skull decoration on the guitar strap give character to the figure. Although these are small details and not immediately noticeable, they provide important information and add interest.

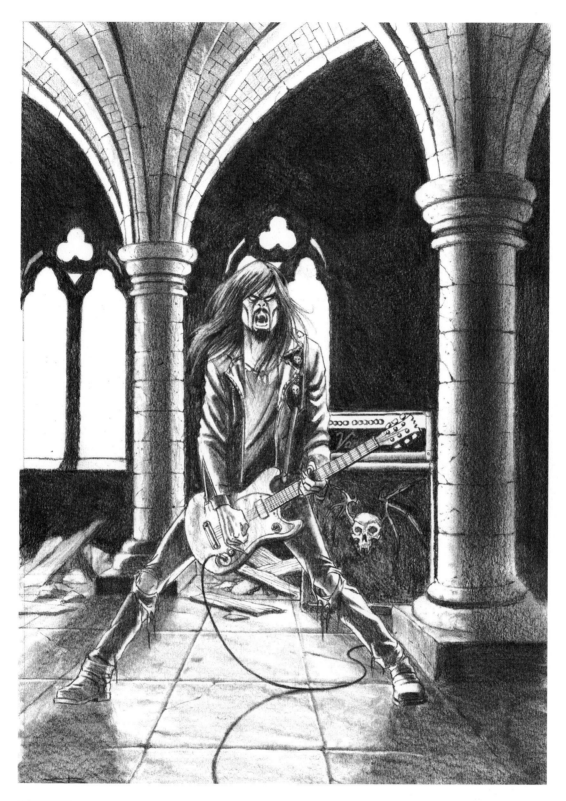

STEP 11

Once all the pencil work is finished, sit back and assess the drawing. Are more highlights required? Does the line-work need more blending? I did some additional blending on the stone floor using a blending stump and added some subtle highlights to the stonework, pillars and figure using the sharp end of an eraser.

At this stage you could stop, since the pencil drawing is now complete. Alternatively, you could ink the drawing in black ink, color it using markers, or do as I did and scan the image and color it using Photoshop.

Figure 7

The rough color work in Figure 7 was created early on, after I produced the thumbnail sketch. I scanned the image, imported it into Photoshop and created a color scheme. At the time I thought the colors worked, but when I looked at it again I realized that the tones were not correct for giving the impression of the setting sun seen through the window. When I came to produce the final image I decided to keep the color palette simple, as I do for most illustrations.

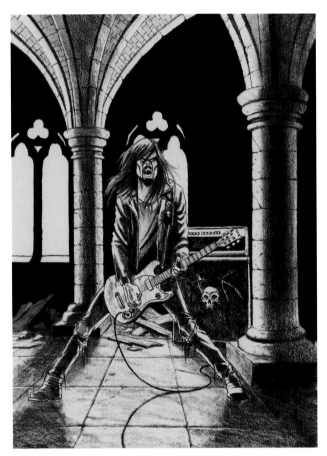

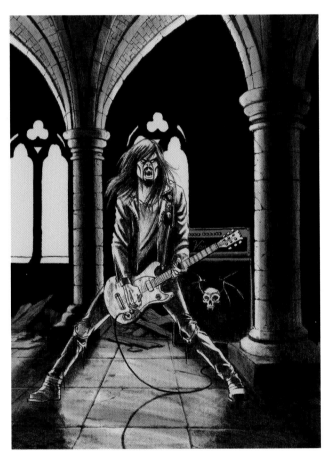

STEP 12

Once you have imported the final pencil illustration into Photoshop, create a base color layer of pale orange by using the Fill option on a low opacity on the Multiply setting. All the brushwork here was done using a single brush I created by scanning a pencil rubbing. You may have other brushes that better suit the way you work—try things out and have fun experimenting.

STEP 13

Create a new layer, set to Multiply, and use a brush to add a pale olive green to the shadowed areas of stonework. Notice how this immediately changes the atmosphere of the piece.

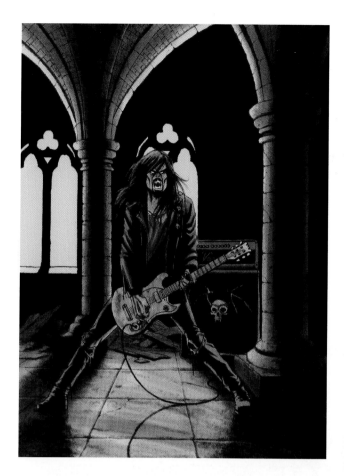

STEP 14

Continue to build up tonal work on the stone with separate layers of pale olive and warm grey, set to Multiply, until you achieve a range of subtle tones.

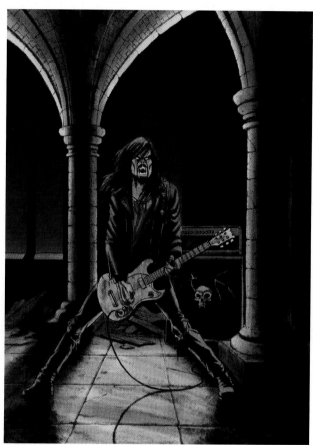

STEP 15

Color the sky, seen through the window, using three layers. The first layer is orange, the second is red and the third is a darker red with a hint of black, which I used for the darker upper tone. All layers should be set to Multiply.

STEP 16

To finish off the interior of the church, apply a few layers of orange. I adjusted the opacity of the first layer to create the right tone to blend with the olive colors underneath. Then I built up the darker, warmer tones with deeper shades of orange, the last of which had a percentage of grey in it.

Exercise 5 ROCK 'N' ROLL VAMPIRE ◦⟨◦⟩◦ **79**

STEP 17

Once you are happy with the setting, focus on the figure. Strengthen the shadows using a dark warm grey and refine the features of the face. Add details to the guitar. Finally, add bloodstains and spatters around the vampire's mouth and clothing and on the guitar.

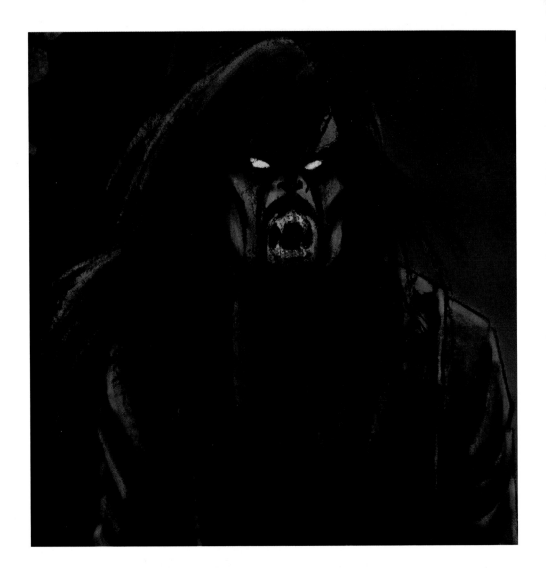

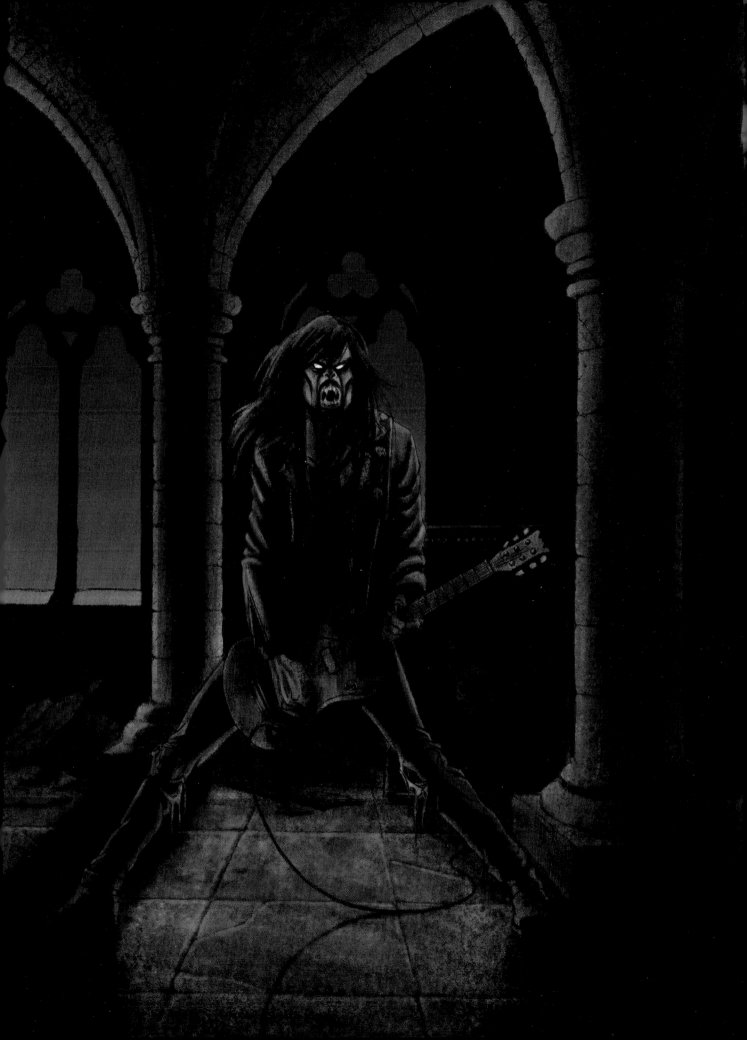

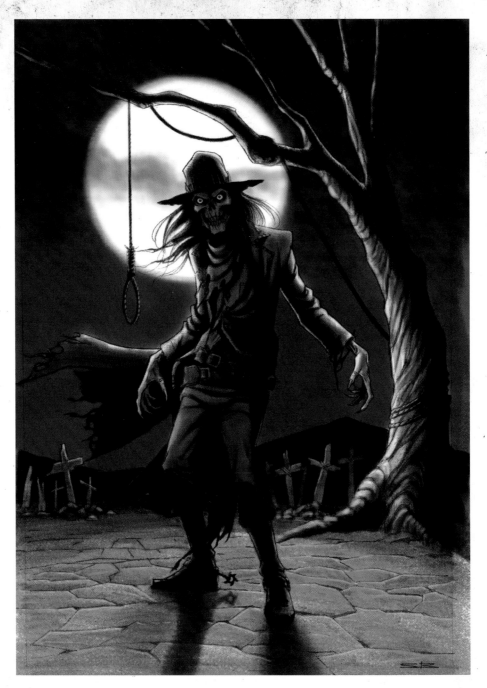

EXERCISE 6

WILD WEST REAPER

I'm a big fan of zombie movies and Gothic Westerns. I love the imagery of Sam Raimi movies such as *The Evil Dead* and *Darkman* and the highly stylized camerawork of Sergio Leone's Spaghetti Westerns. One of my favorite scenes in *The Good, the Bad and the Ugly* is the final showdown in a parched graveyard. With that in mind, I came up with the idea for this midnight scene with a ghostly gunslinger. This image would work well as a pencil drawing or inked in so it stands out more. But I decided to take the piece a step further and color it using Photoshop.

I began by producing some rough ideas in color, using markers. The first idea (Figure 1) shows a classic duel pose that is imposing and menacing. The moon frames the figure, allowing it to stand out against the midnight sky. However, although I liked this layout I didn't think it was creepy enough. I felt the figure needed to look more craggy, other-worldly and less human, so I produced some more sketches in which it has a more skeletal appearance and looks like a rotting corpse. The curve of the back and the legs creates a nice shape and adds to the eeriness of the character without diminishing the sense of threat. I then played around with a couple of color variations to decide upon the right atmosphere (Figures 2 and 3). I felt that a midnight setting created the right mood.

Figure 1

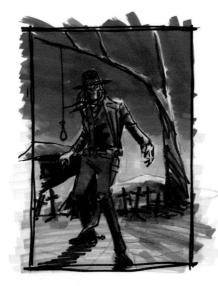

Figure 2

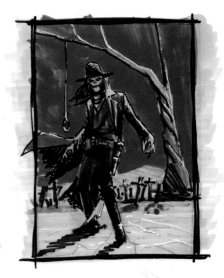

Figure 3

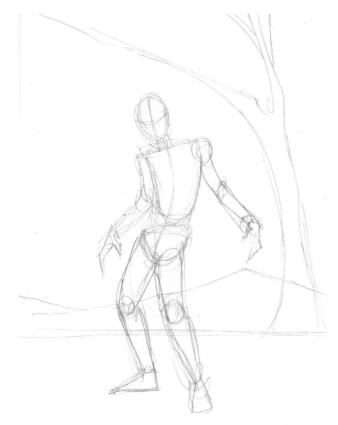

STEP 1

Having sketched out the drawing in rough, you can start afresh on a clean piece of paper. My drawing was produced on 300gsm rough cartridge paper using a combination of a Palomino Blackwing 602 pencil and a HB Staedtler pencil. Begin to plot the drawing, making the tree in the background echo the shape of the figure. Notice the low horizon line. When drawing the character, keep in mind the tips on figure drawing (see page 10) and break down the form using whichever method you prefer. Here, I used construction shapes.

STEP 2

Once you are happy with the basic stance, you can flesh out the figure and add clothing. Because I watch so many films and read so many comics, my head is crammed full of visual references and information I can draw upon. For this project I called upon my visual memories to create a hybrid of Sam Raimi's *Darkman*; the cowboys in the train station scene in Sergio Leone's *Once Upon a Time in the West*; and Virgil Cole in Ed Harris's *Appaloosa*. Combining references in this way may not create an authentic Wild West visual, but this is fantasy art, and using artistic license is a lot more fun than slavishly reproducing stereotypes.

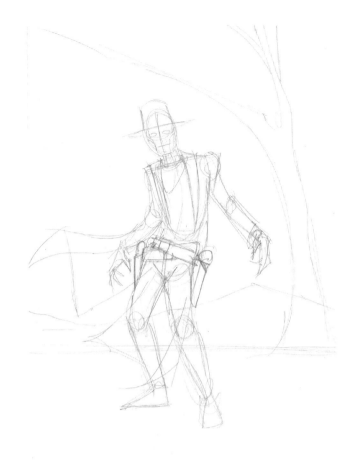

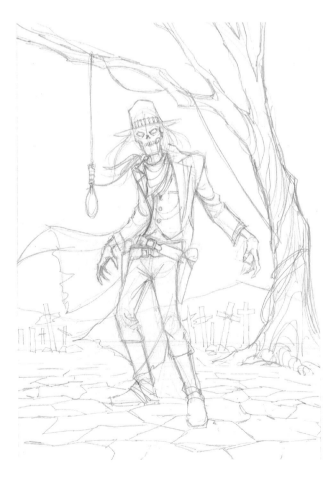

STEP 3

Now you can add details to the background and the figure. Think about each element and how it impacts the atmosphere. In my drawing, the tree has taken on a more twisted, craggy appearance and I've added a hangman's noose to further frame the figure. I have made the wooden grave markers more weathered and beaten. The hills in the background, once blackened, will add contrast and make the grave markers stand out more. I have given the figure long, wispy, tatty hair on his skull-like head, which contributes to his creepy appearance, and added details to his clothing so he looks more like a zombie gunslinger.

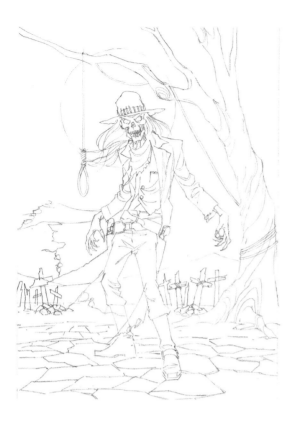

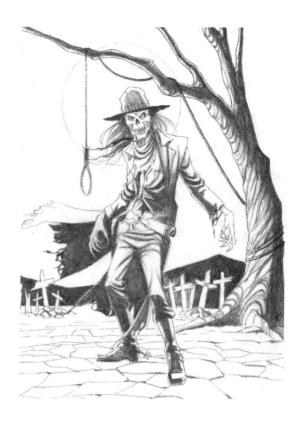

STEP 4

Once you are happy with the image, trace the outlines onto a piece of cartridge paper using a pencil and lightbox, if necessary. If the original sketching is drawn softly, you can simply clean up the drawing using an eraser.

STEP 5

Fill in all the dark areas that will lend the drawing strength, then use a blending stump to blend the pencil work for a smoother finish.

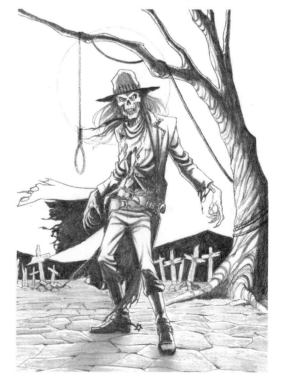

STEP 6

Add light and mid-tones to the ground and clothing using a pencil. I have purposely left more areas of lighter tone on this drawing to enable me to color and light the image in Photoshop. Even if you are producing a monochrome version of this drawing, it is a good idea to leave lighter areas so that the drawing does not look too flat.

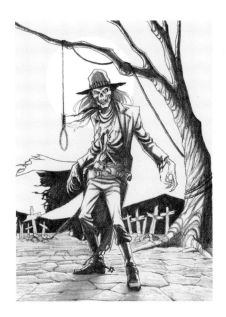

STEP 7

Once you are happy with the pencil work, you can either stop, or try coloring the image. You may choose to use paint or markers, but I used Photoshop for this artwork. Scan the drawing and import it into Photoshop. Create a pale blue base layer and set to Multiply, using the Fill option and adjusting the opacity.

I decided to add a full moon in the background so the figure stands out well in the foreground. I was hesitant at first, as I thought this detail might be a bit clichéd, but I found that it actually added to the mood of the scene.

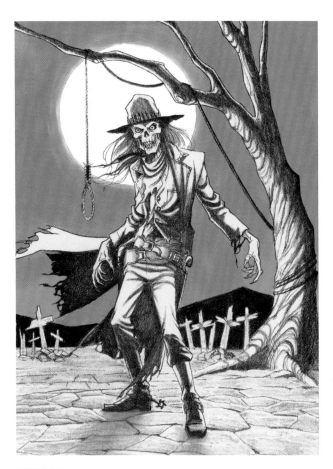

STEP 8

On a new layer, set to Multiply, add a darker shade of blue to begin the build-up of tone for the midnight sky. I used a brush I created by scanning some pencil rubbings and then raising the contrast. I find this digital brush works in a similar way to a real brush, creating comparably rough or broken strokes.

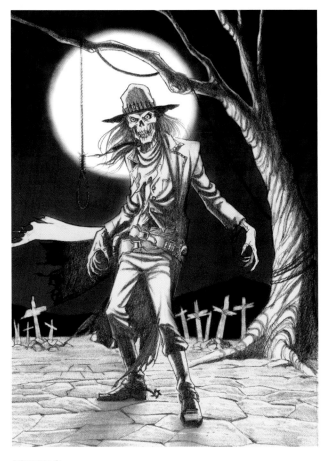

STEP 9

Add an ultramarine tone as the final layer of blue, again set to Multiply. On another layer, set to Multiply, apply some dark grey at the top of the image to keep the sky from looking too flat. I also used the blue to wash over the hills in the background to darken their appearance.

STEP 10

Apply a mid-grey layer set to Multiply to darken the ground. You can adjust the opacity setting to create the right amount of tone. A mid-warm grey tone layer makes the clothing just different enough in color for the figure to stand out from the background. I have purposely left rough highlights around the edge of the figure so that it doesn't get lost against the background color.

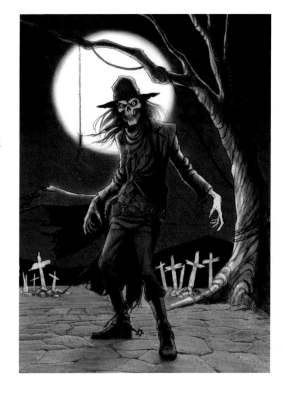

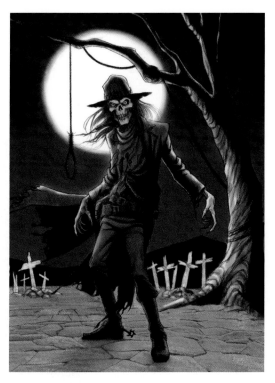

STEP 11

Using a dark grey layer, set to Multiply, apply the heavy darker tones to the hills, the figure and the tree, giving strength to the image. I tried applying a black layer, but it was too heavy for my taste, so I opted for a grey.

STEP 12

Apply layers of pale warm greys to the clothing and face to blend the colors and add more depth. All layers should be set to Multiply.

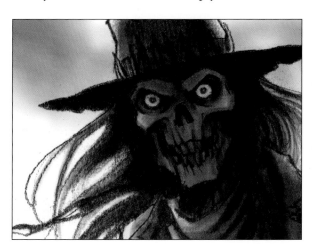

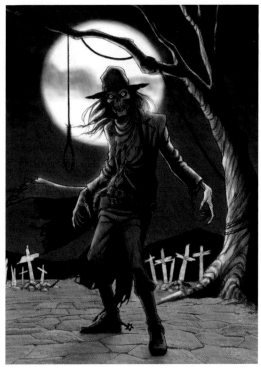

STEP 13

Build up the deeper, darker tones of the face and hands using pale blue-greys and warm greys set to Multiply. Adjust the opacity on each layer if you feel that some of the brushstrokes are too harsh.

In reality, a figure situated in front of such a bright moon would be cast in silhouette. However, I wanted some of the character's features to be visible so I took some artistic license with the lighting.

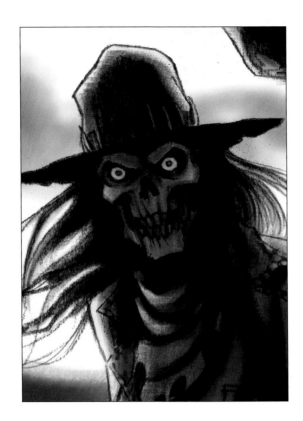

STEP 14

Finally, add some highlights to the figure, the grave markers, the cracks in the ground and the tree. For this I used an opaque layer of pale blue. This is the only layer I have used on the Normal rather than the Multiply setting. I adjusted the opacity to slightly reduce the opaqueness of the highlights. Check that you are happy with the final image, and make any adjustments you want.

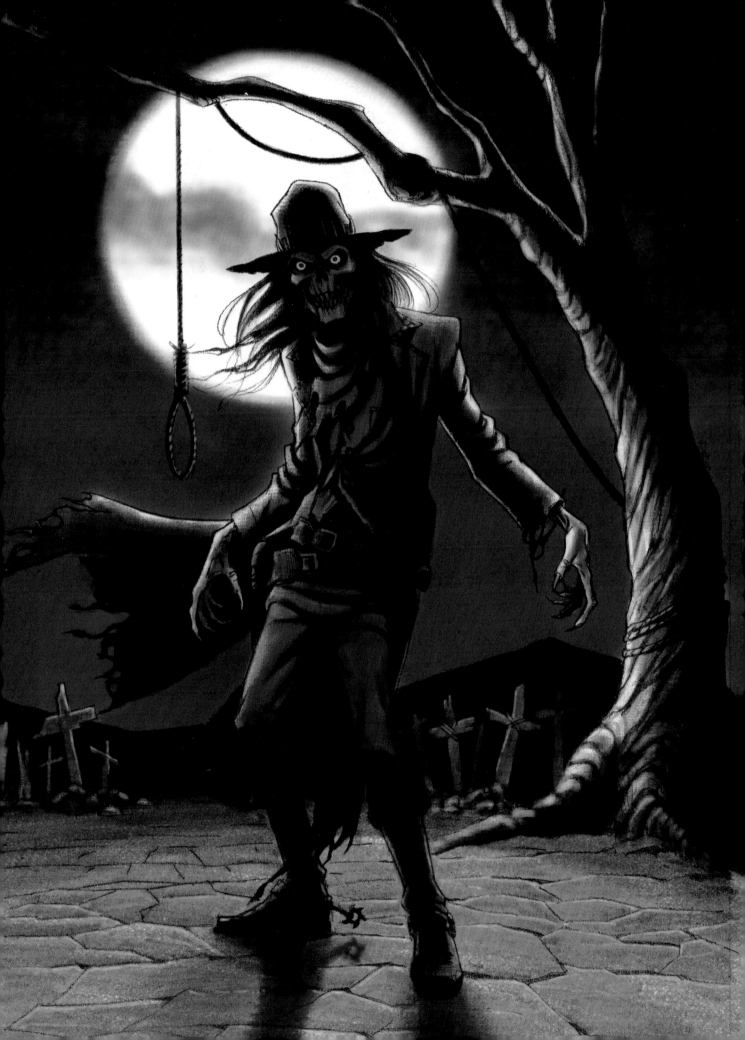

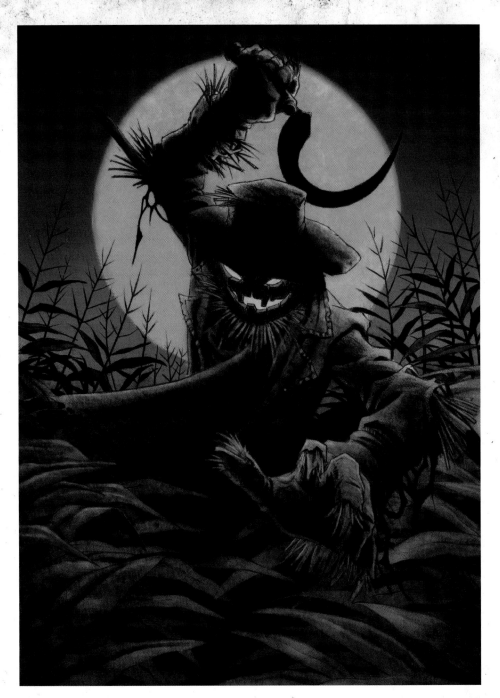

EXERCISE 7

HALLOWEEN

As a child, I was taken to see Walt Disney's animated feature film *The Adventures of Ichabod and Mr. Toad* (1949), which contains the tale of *The Legend of Sleepy Hollow*. I loved the story and imagery of Ichabod Crane and the Headless Horseman. As a teenager, I went to see Tobe Hooper's *The Texas Chain Saw Massacre* (1974) and was equally impressed by its macabre visuals and narrative. Imagery from both films informs this drawing, as well as references from other sources, and, of course, my imagination.

Initially, this character was going to be a creepy-looking scarecrow that had been brought to life to terrorize a remote run-down farm with a rusty but lethal sickle. I sketched a few ideas of a sack-headed scarecrow (Figure 1), which I thought had some merit, but I decided they looked too much like the DC Comics character The Scarecrow, one of Batman's well-known adversaries. So I changed tack and developed a series of thumbnail sketches of a pumpkin-headed scarecrow in order to find the right content and layout.

Figure 1

The first ideas I developed depicted a scarecrow terrorizing a young farm boy (Figure 2). Although I liked these, I was not completely satisfied with the tone and atmosphere. Then I remembered the 1974 promotional posters for *The Texas Chain Saw Massacre*, a simple yet striking image that showed the central character, Leatherface, waving a chainsaw above his head in a field of crops. Nothing else—no other people in the shot. I realized that the power of the image was derived from the uninterrupted connection between Leatherface and the viewer, and that by removing the figure in the foreground of my drawing I would be able to create a similarly strong link.

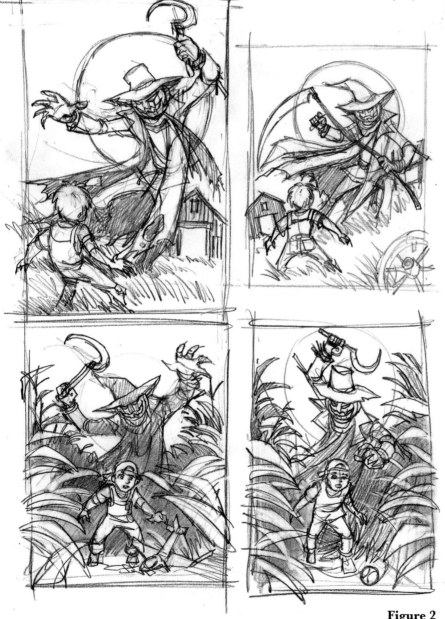

Figure 2

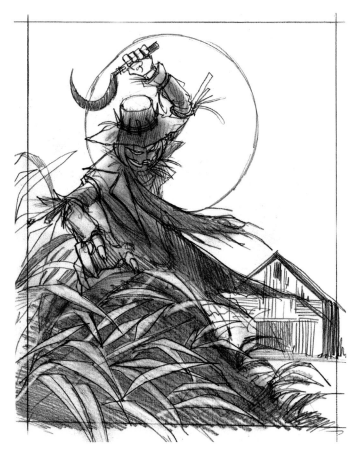

Figure 3

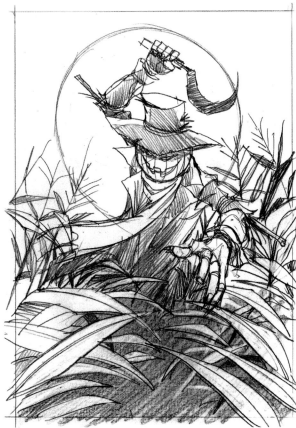

Figure 4

With this in mind, I developed two more thumbnail sketches (Figures 3 and 4), which I felt worked much better. I really liked the wide shot (Figure 3), which allowed me to introduce background details such as the barn and to recreate the atmosphere of *The Texas Chain Saw Massacre* poster. However, I eventually decided on the tighter shot (Figure 4), as it draws the viewer closer to the menacing scarecrow.

Before developing the final drawing I explored a few styles of a pumpkin head to see which had the right creepy vibe (Figure 5). I thought jagged teeth would look scary, but once I had drawn them I felt they looked a bit clichéd. I decided in the end to go for a classic Halloween pumpkin, which was more understated but created the visual I was looking for. You may want to give your pumpkin jagged teeth—as with most details when drawing, there is no such thing as right or wrong—it all comes down to personal preference.

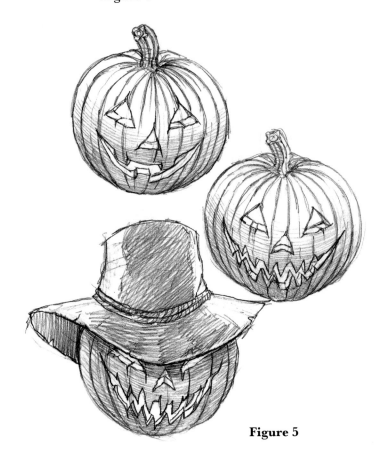

Figure 5

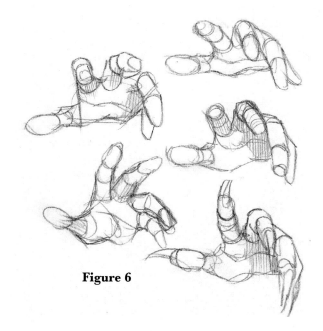

Figure 6

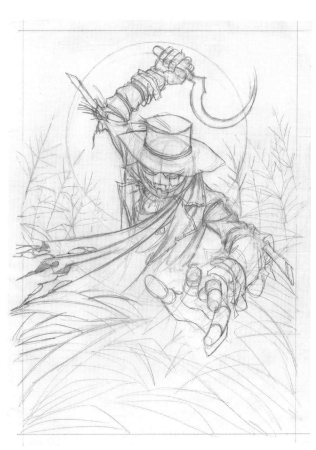

STEP 1

As the artwork has a central composition, it makes sense to plot the drawing around a center line. I roughly marked out the shape the crops would make (Step 1). You will notice that this echoes the shape of the sun.

I wasn't completely satisfied with the hand reaching out that I had drawn in the original thumbnail sketch. I therefore held my hand in various positions and used a mirror to see how it looked, then drew a series of sketches (Figure 6) so that I could assess which pose would work best.

STEP 2

Start filling in the details, sketching the crops before you begin work on the figure. I drew the stalks coming into the frame from the outer edges of the paper, growing less dense as they reach the center. It may look as though I have drawn a lot of randomly placed leaves, but when you shade in the picture you will notice that their arrangement creates a dark, shadowy space in the middle that draws your eye to the scarecrow.

For the clothing, I chose to draw a ragged overcoat, scarf and hat, the style and details of which are obscured by the rips, tears and general dirtiness of the garments. The gloves are workman's gloves—the type a farmer or construction worker might wear.

The clothing is baggy and the skeletal structure of the scarecrow is based on a wooden cross-shaped frame rather than a human body. I wanted the arms to be long and thin—reminiscent of a scene in the Wes Craven movie *A Nightmare on Elm Street*, in which Freddy Krueger chases a victim down an alley with his spindly arms reaching out to the walls, preventing any chance of escape.

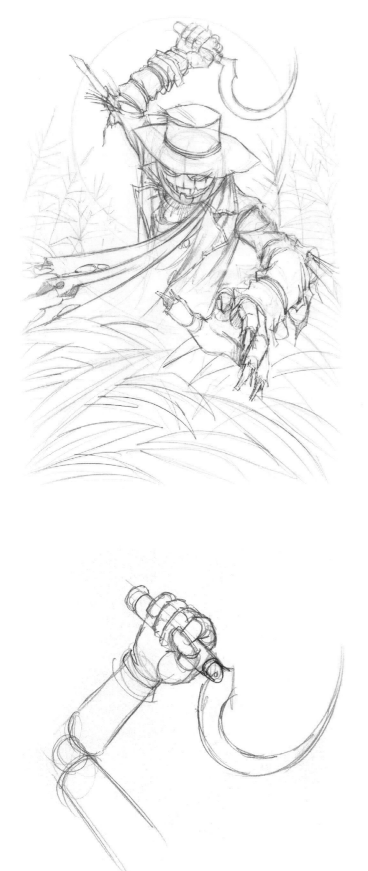

STEP 3
Having plotted the drawing, take a step back and assess it. When I studied my drawing, the raised arm holding the sickle caught my eye right away; everything about it just looked wrong. I then replicated the pose in a mirror and found that the position of the arm was not correct. After studying the pose carefully, I returned to my desk and practiced redrawing the arm on scrap paper before amending my drawing (Figure 7).

STEP 4
Check the drawing one more time, then trace the image onto a sheet of cartridge paper using a pencil and a lightbox, if you have one. You should now have a clean, accurate outline to work with (Figure 8, opposite).

Figure 7

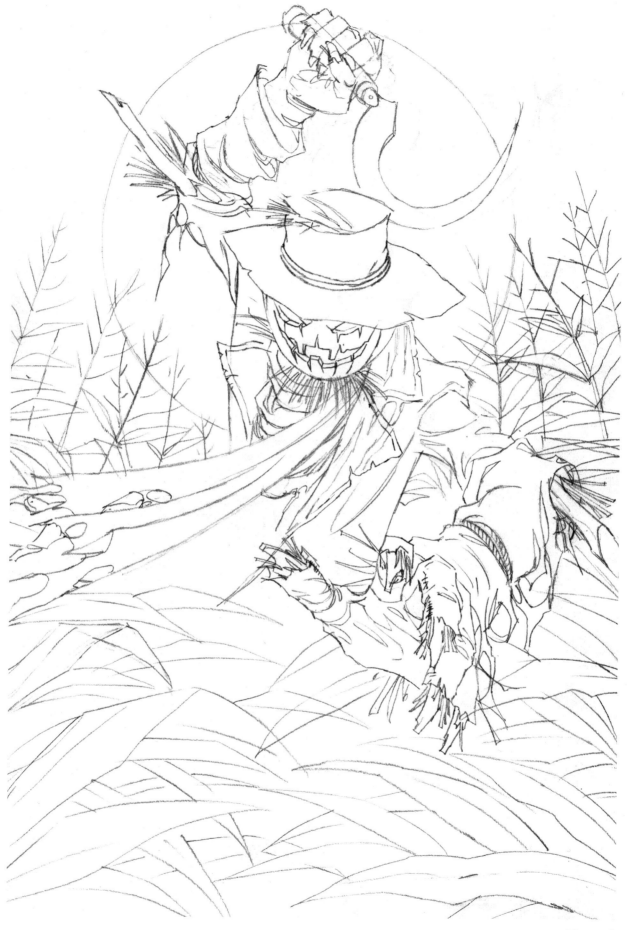

Figure 8

Exercise 7 HALLOWEEN ◦⟨◦⟩◦ **95**

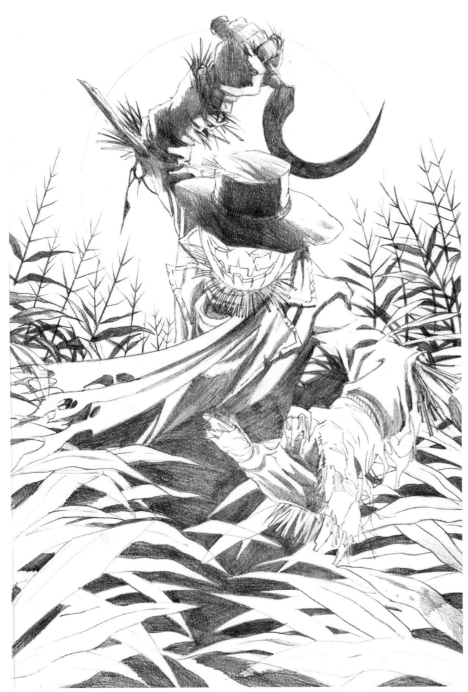

STEP 5

Using a Palomino Blackwing 602, darken the areas that will give the image its strength and weight. You may notice in my drawing that the darkened areas run up the center of the page, creating a linear design. This is a deliberate device to make sure the viewer's eye does not wander away from the main point of interest.

STEP 6

Use a blending stump to achieve a smoother, more opaque finish on the darker areas of shading. Figure 9 on the facing page shows the finished result. As a pencil drawing, this artwork is now complete. However, you can take it a stage further and add color, as I have done, if you like.

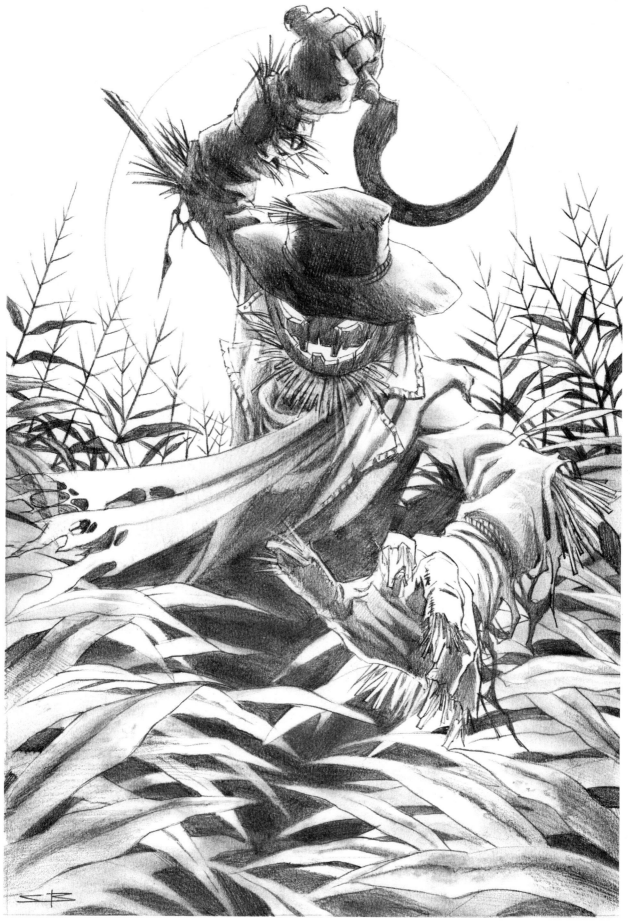

Figure 9

STEP 7

Scan the drawing and import it into Photoshop. Apply a first layer of base color using the Fill option, set to Multiply. Here, I used a very pale warm yellow as a foundation for the warm tones.

I added color to the sky in three layers. The first of these was a deep orange, over which I placed another layer of deep red, followed by a layer of dull red with a percentage of black in it to create the darker tones at the top. All the layers were set to Multiply. I mainly used just one brush to apply the coloring. This is a customized brush I created from a pencil rubbing (Figure 10), but it is likely that there are similar brushes available on the internet that you can download for free.

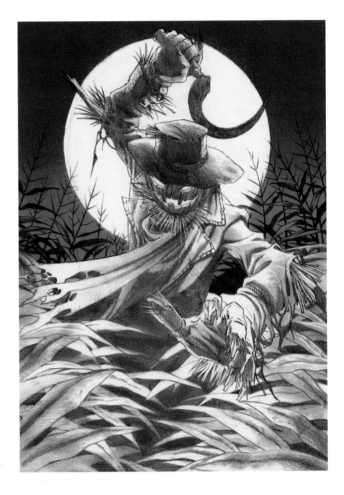

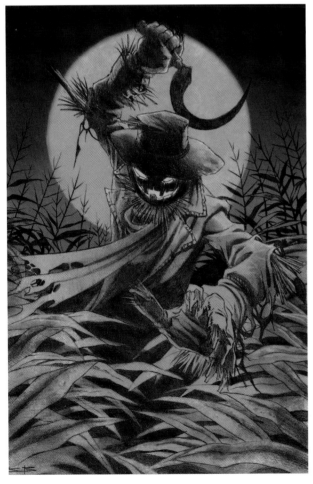

Figure 10

STEP 8

On another layer, apply a rich deep orange for the sun. Use the same orange for the rest of the image, but put it on a separate layer in case you need to adjust the opacity to blend with the olive tones that are going to be added. Both layers should be set to Multiply.

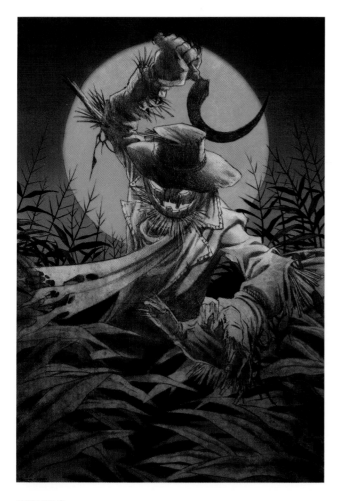

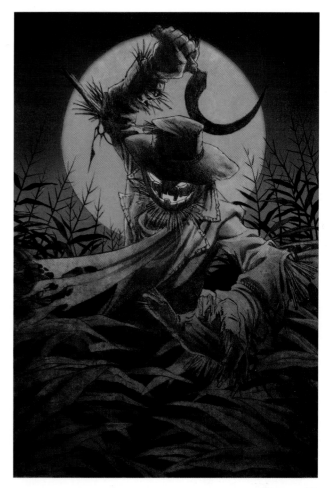

Figure 11

STEP 9

Begin to build up the colors for the crops using layers of olive green. In this step picture I have deselected the orange layer, shown in Step 8, so you can get an idea of the tone of the green, but you don't need to do this. I have merged the green with the outline of the scarecrow in order to create a subtle tonal blend as I apply other colors. All layers are set to Multiply.

I have returned the orange layer in Figure 11 to show how the color blends with the olive greens, creating rustic and darker tones.

STEP 10

Enlarge the diameter of the brush tool, zoom in and dab the olive green over details such as the leaves to create textural detail and interest.

STEP 11

On another layer,
using the same brush
and a dark warm grey,
apply texture to the
scarecrow's clothing.
With the layer set to
Multiply, create a denser
grouping of strokes to
create darker tones.

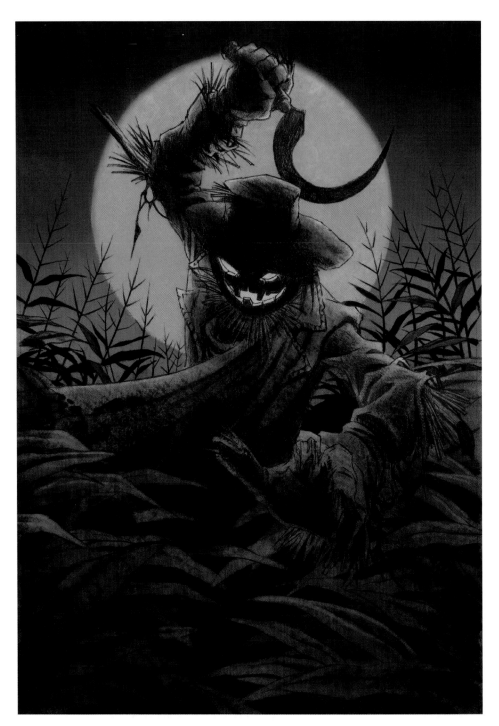

STEP 12

Create the darkest tones
using a dark warm grey
that is about 25 percent
lighter than a solid black.
I applied this to the
scarecrow, the really dark
areas of the crops at the
bottom of the picture and
the silhouetted crops in the
background.

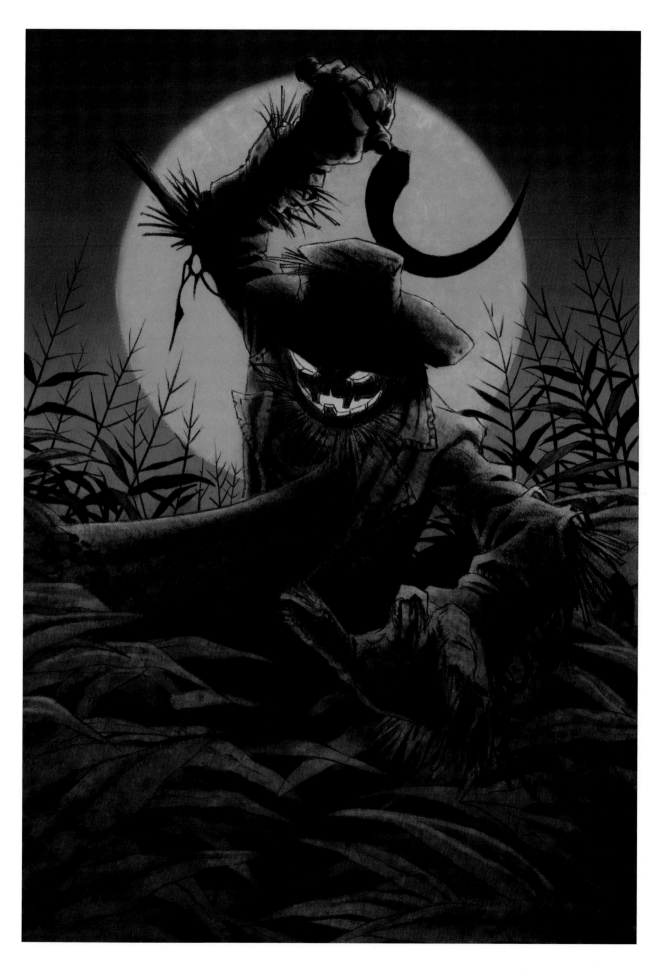

STEP 13

On the top layer, apply yellow and light orange highlights to the scarecrow to make him stand out even more from the darkened background. The highlights should be set to Normal rather than Multiply (meaning they are opaque rather than transparent). Use highlights to pick out the gloved hand reaching toward the viewer and on the clothing and straw hat, both of which have light cast on them from the glowing pumpkin head.

STEP 14

Finally, apply an orange tone to the inside rims of the eyes and mouth to add depth.

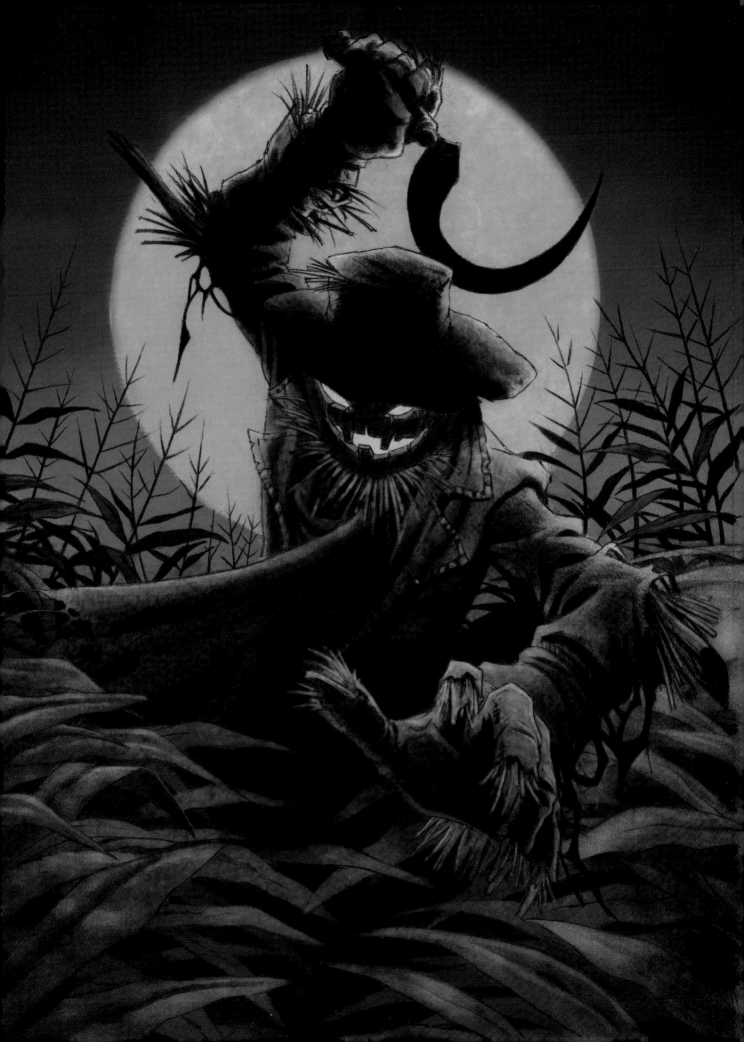

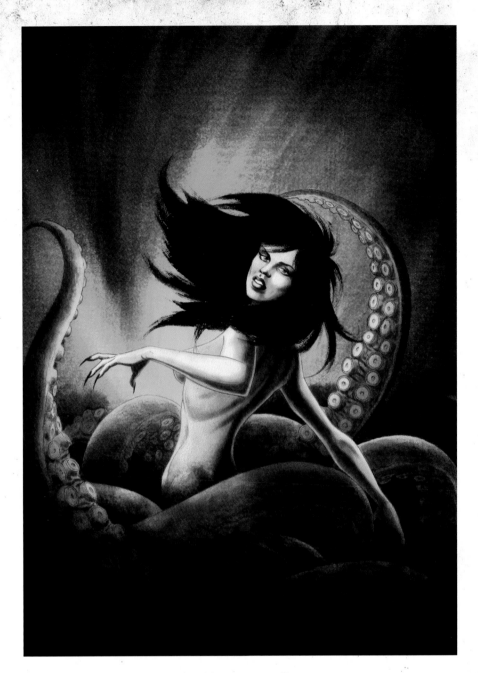

EXERCISE 8

SEA CREATURE

I have always been fascinated by the female villains in classic Walt Disney animated feature films. In my opinion, they steal the show. *Snow White and the Seven Dwarfs* has the fantastically cruel Queen, *Sleeping Beauty* has the magnificent Maleficent, *101 Dalmations* has Cruella de Ville and *The Little Mermaid* has Ursula. I think Ursula is a great character, and she is the inspiration for this exercise. I produced the pencil drawing with a Staedtler HB pencil on Winsor & Newton hot-press 300gsm watercolor paper, with a lamp-black gouache wash for the background.

This strong, eye-catching character was created as a book cover as well as for this exercise. The rough thumbnails (Figures 1–3) on this page give you an idea of the creative process. Figure 1 was one of the first thumbnail sketches I produced, but I was not happy with it so I drew Figure 2, scanned it and imported it into Photoshop to produce some quick color schemes. Eventually I arrived at the approved image, Figure 3. When drawing for a client, it is very important to go through these planning stages and to produce color roughs as well as pencil sketches, but this is not usually necessary if the artwork is for you alone.

Figure 1

Figure 2

Figure 3

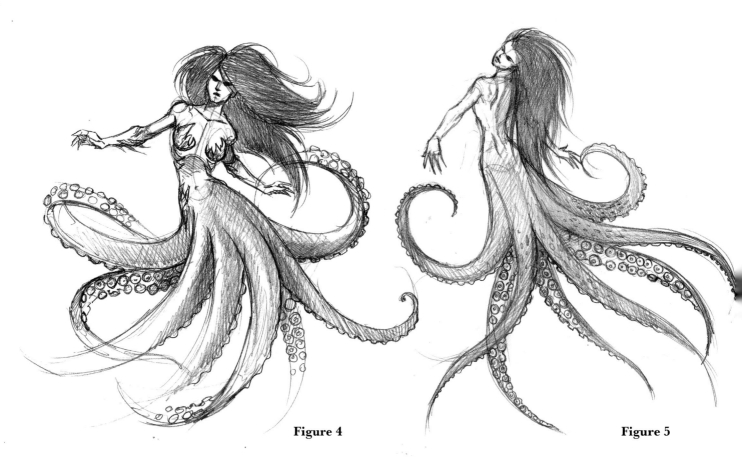

Figure 4

Figure 5

Sometimes, before getting to work on the final drawing, I will spend some time sketching figures and designs to see if the process leads to any new ideas. In the past, I have often produced a drawing and then, after its completion, had some ideas that would have improved it.

I am always learning from studying work by other artists I admire. One artist in particular, Claire Wendling, has produced incredible fantasy creations merging humans and animals that I find greatly inspiring. What makes even her loose sketches so believable is that she watches and studies her subject matter until she knows it so well that drawing it becomes (or so it appears) an

Figure 6

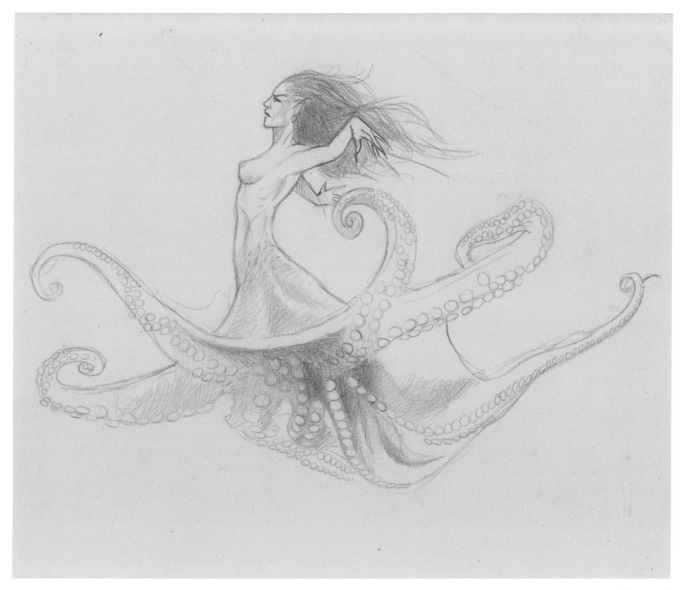

Figure 7

effortless task. So, following Wendling's example, in order to gain a greater insight into the subject of this piece, I took a trip to an aquarium and watched and sketched an octopus swimming. Upon returning to my studio I then adapted the sketches into some rough concept work (Figures 4–7).

Pictures from the internet and television documentaries (Figure 8) are also good references when studying wildlife, especially if you do not live near a place where you can study your subject matter firsthand. If you have pets—whether it be a cat, dog, reptile or fish—spend some time drawing them. It is fun to do and will develop your observational skills as well as improving your drawing abilities.

Figure 8

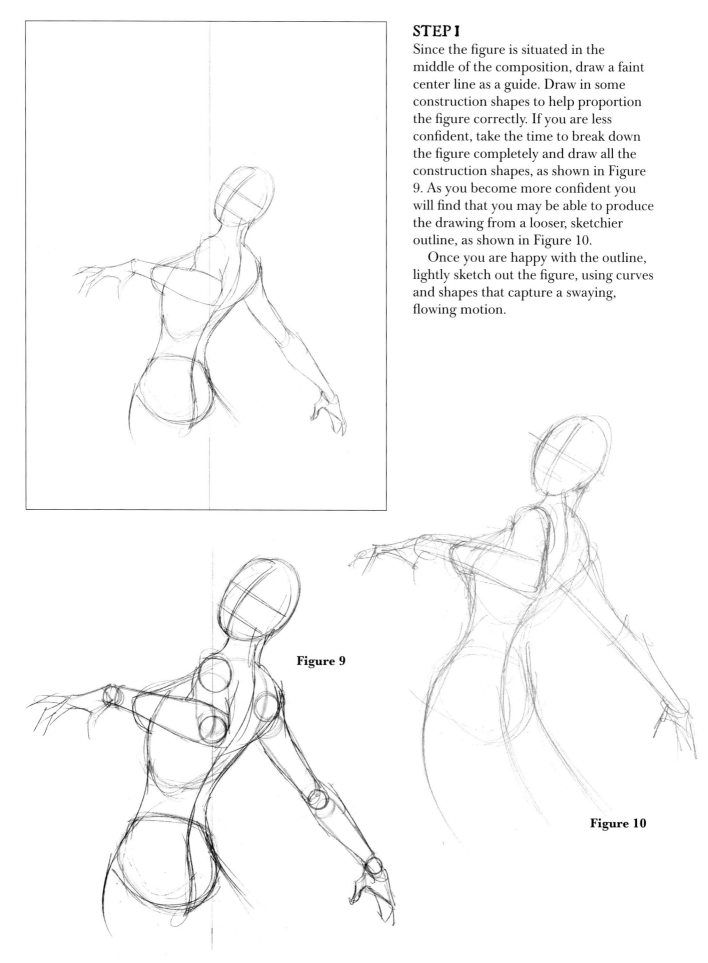

STEP 1

Since the figure is situated in the middle of the composition, draw a faint center line as a guide. Draw in some construction shapes to help proportion the figure correctly. If you are less confident, take the time to break down the figure completely and draw all the construction shapes, as shown in Figure 9. As you become more confident you will find that you may be able to produce the drawing from a looser, sketchier outline, as shown in Figure 10.

Once you are happy with the outline, lightly sketch out the figure, using curves and shapes that capture a swaying, flowing motion.

Figure 9

Figure 10

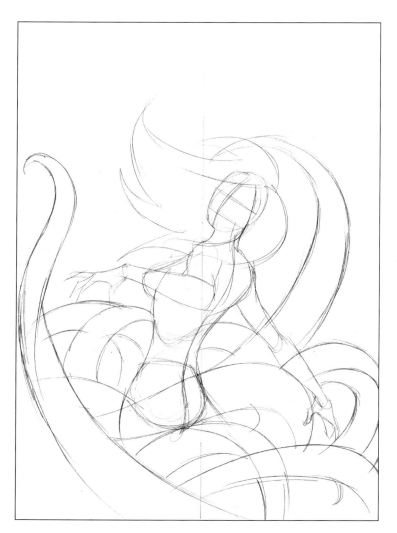

STEP 2

I wanted to create a menacing, writhing mass of tentacles. To do this I stopped trying to accurately depict how real-life tentacles would flow and instead used some artistic license and positioned them so that they looked right for this piece and created the desired impact.

The arrangement of tentacles may look a bit complex at first glance, so in Figure 11 I have added some color to identify the shapes more clearly.

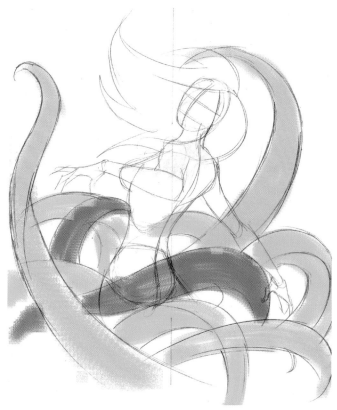

Figure 11

STEP 3

When drawing the face, remember the tips covered in the introduction. One of the best ways to draw an attractive, young-looking female face is to keep the line work soft, and by that I mean using curves instead of hard edges. Keep the cheekbones rounded and soft. Do the same with the eyes and lips. Avoid drawing too many lines around the eyes as this can make the face look old, unless of course this is the effect you want to achieve.

I tend to stylize the eyebrows and eyelashes into solid shapes (Figure 12). This keeps things simple and saves time, since not every single hair needs to be drawn. If you look at someone's face from a distance, you do not really see every hair and eyelash anyway—you see a collective shape.

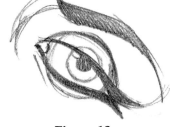

Figure 12

STEP 4

When it comes to drawing hair, keep things simple at first. I based the shape of the hair here on the style used by Disney artists. If you want to add some detail, remember that hair strands all flow from the scalp, so group the line work accordingly (Figure 13).

Figure 13

Figure 14

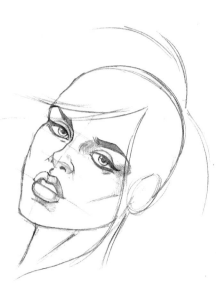

Figure 15

STEP 5

Having established the hair and face, add the details to the tentacles, returning to pictures of octopuses and other references, if needed.

STEP 6

Once you are happy with the outline of the figure, add the shading. Notice the simple shape of the lips and nose (Figure 14) and the light, uncomplicated shading around these areas and around the eyes (Figure 15).

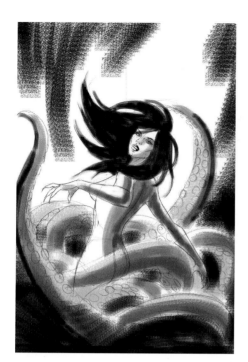

STEP 7

Before you begin adding the final solids and shading, scan the working drawing and import it into Photoshop. You could also take a photocopy of your drawing and work on the copy, or trace your working drawing onto a clean sheet of paper. In this instance, I used Photoshop since I have access to this resource. I chose to use three layers of tone and spent some time working out the strengths of each and where they would be placed. I decided in the end to position the main light source in the background in order to isolate the main figure. This means that all the heavy shadows will be at the back of the figure, as shown.

STEP 8

Once you have established the placement of the solids and tones on the computer image, return to the pencil drawing and add the final pencil work. I began by applying solid black gouache to the hair. If you are drawing on cartridge paper and not planning to use paint or ink, use a soft lead pencil for the hair and make it as dense as possible. If you are using watercolor paper then it is a good idea to stretch it and tape it down with masking tape before applying paint (see page 50), or you could risk warping the paper.

If you study someone with long, dark hair swimming underwater, you will notice that the hair becomes one dark flowing mass. Unlike lighter or blonde hair, it is difficult to see individual strands of dark hair. Try to recreate this in the drawing.

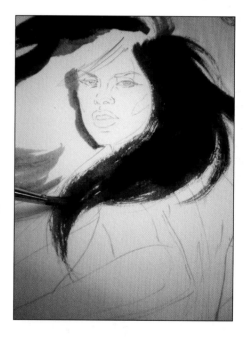

STEP 9

Build up the skin tones on the body by applying softer, lighter shades at first; then add darker, heavier pencil work over the top.

STEP 10

Check the shading on the face and strengthen the eyes and mouth with heavier pencil work, taking care not to press too hard.

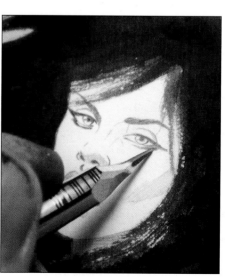

STEP 11

Apply a wash of lamp-black gouache to create the background effect. As with any watercolor, gouache or ink wash, the result can be random and a little unpredictable. How the wash dries will vary each time and will create different patterns, so don't try to create an identical background to mine—see what develops with your own wash.

STEP 12

Add texture to the tentacles by using the flat edge of the pencil and light pressure to create a random swirling pattern. Blend the texture. I used some tissue paper rather than a blending stump, as I wanted just a subtle blend. Repeat the process, adding texture over the top of the blended work to create a denser finish.

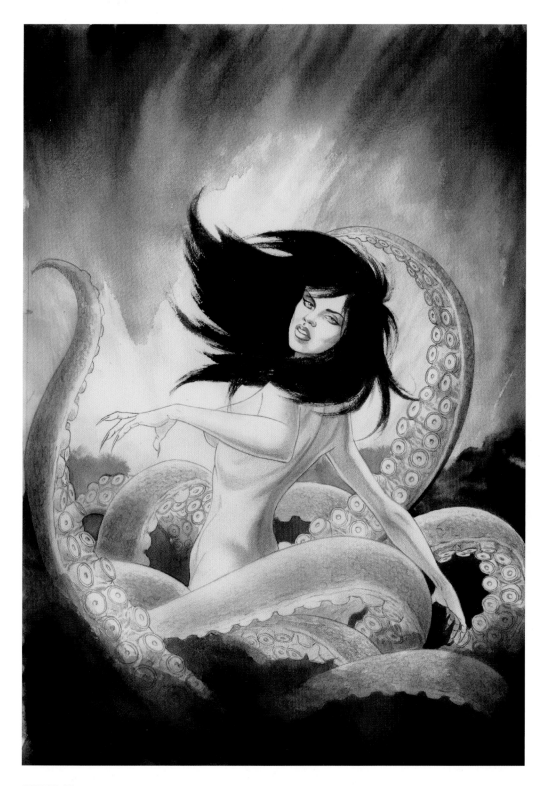

STEP 13

Once the pencil-and-wash drawing is complete and dry, scan the artwork and import
it into Photoshop. If you do not have Photoshop or any kind of graphics package, but
want to color your drawing, you should be able to follow a similar procedure using
watercolors: start with light, pale colors first and gradually build up darker tones by
applying multiple layers of color.

 I applied a base layer of cold, pale green, set on Multiply. Look at the colors
presented here merely as a guide and choose your own color palette. You may find
shades and combinations that are more pleasing to your eye.

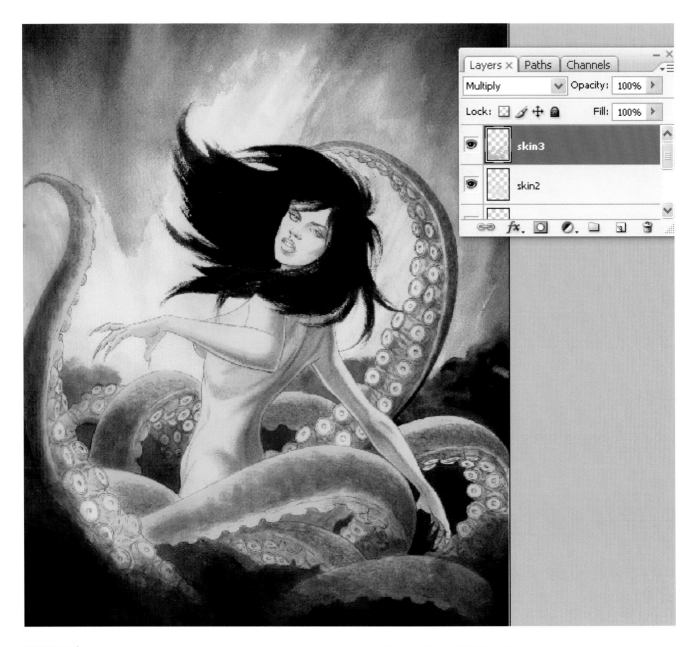

STEP 14

Usually I color the backgrounds first, but in this case I began with the figure in the foreground. You can work the other way around if you prefer. Start to build up the skin tones using darker greens by selecting a textured brush. The one I used for the skin here is a scan of a pencil rubbing I created by rubbing a pencil across a piece of paper placed over a rough surface (Figure 16). I initially focused on building up the darker areas along the figure's back, arms and on other features in shadow, furthest from the light; then I created a new layer and used a lighter green for the rest of the skin tone, set to Multiply.

Figure 16

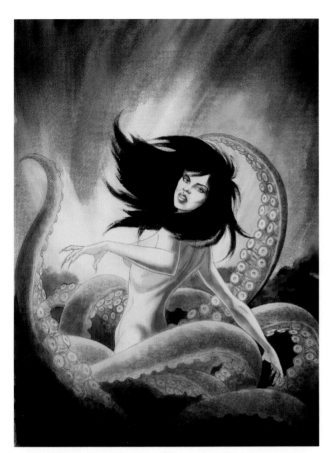

STEP 15

Introduce transparent shades of pale blue over the green to create subtle blends of color tone. These are simply rough, broad strokes initially, but they will appear less coarse when more layers are applied over the top. All layers should be set to Multiply.

STEP 16

Apply darker tones of green and warm greys. Here you can see the greys around the eyes, the underside of the nose and on the lips.

STEP 17

Add darker, denser tones of blue around the outer edges of the image, as these will draw your eye to the lighter center, where the character appears. Apply the same blue tones to the tentacles, on another layer and on Multiply, with the opacity set at 50%.

STEP 18

Add a scaly texture to the lower part of the body using tones of grey and blue. I used a brush I had created by scanning some paper on which a marker had been randomly blotched (Figure 17).

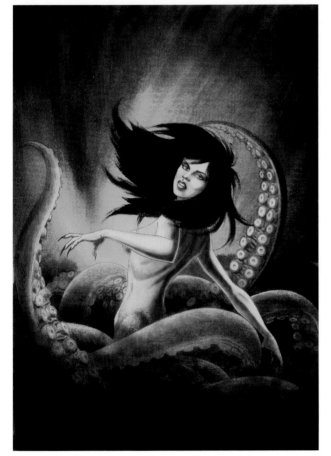

Figure 17

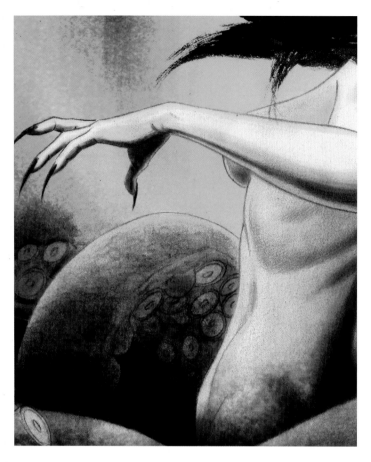

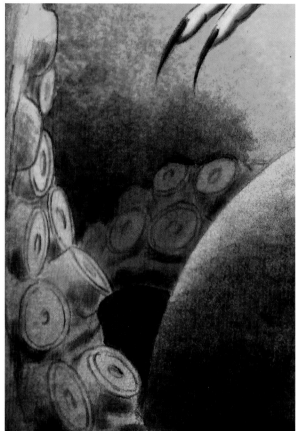

Figure 18

STEP 19

Add tones of yellow to the background to further separate the figure in the foreground from the background. Apply highlights of yellow, set to Normal rather than Multiply, to the figure and the tentacles (Figure 18).

I used the brush I had employed for the scales, but set to a wider diameter, to create a murky, cloudy effect that suggests a disturbance of the sea floor (Figure 19). I started with a low opacity setting and a mid-strength grey and built up the effect by increasing the opacity.

Figure 19

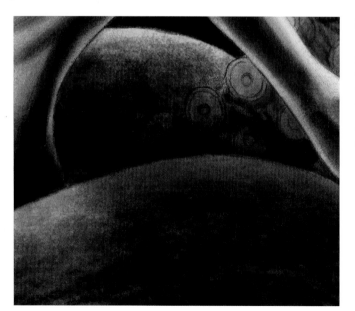

STEP 20

Finally, add some darker reflected shadows to the rear tentacles using blue-grey tones. I used a brush pattern I created by dabbing ink onto paper with a coarse sponge (Figure 20).

Figure 20

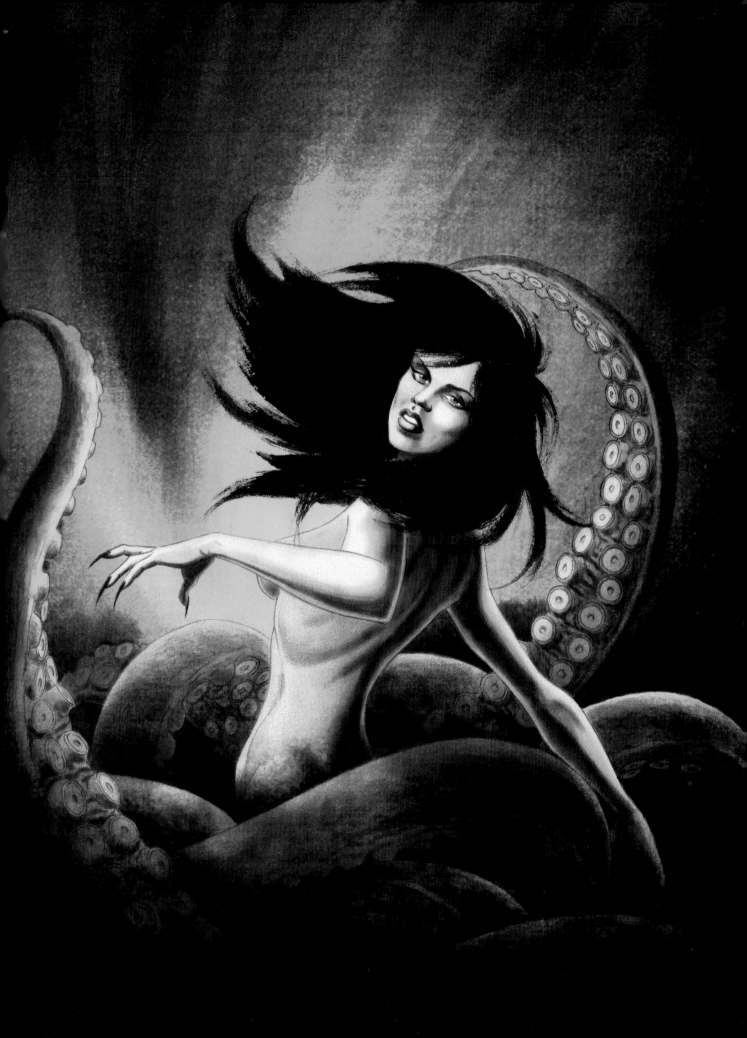

SKETCHBOOK

I often stress the importance of keeping sketchbooks to my students. They can be used for any kind of drawing—from observational sketches or the exploration of ideas to testing out new materials (pens, pencils, paints, etc.) or just doodling for the fun of it. All these activities help to develop drawing skills, and, as with most things, the more you practice, the better you become.

Professional artists fill dozens of sketchbooks. The rough workings of some, including Frank Frazetta, Jeffrey Jones and Claire Wendling, have been turned into high-end art books that showcase their creative processes. The seeds of some of your best ideas may be doodled in a sketchbook. Ideas flow uninhibited when you are not feeling too precious about your drawing, and you may often experience a breakthrough in this way.

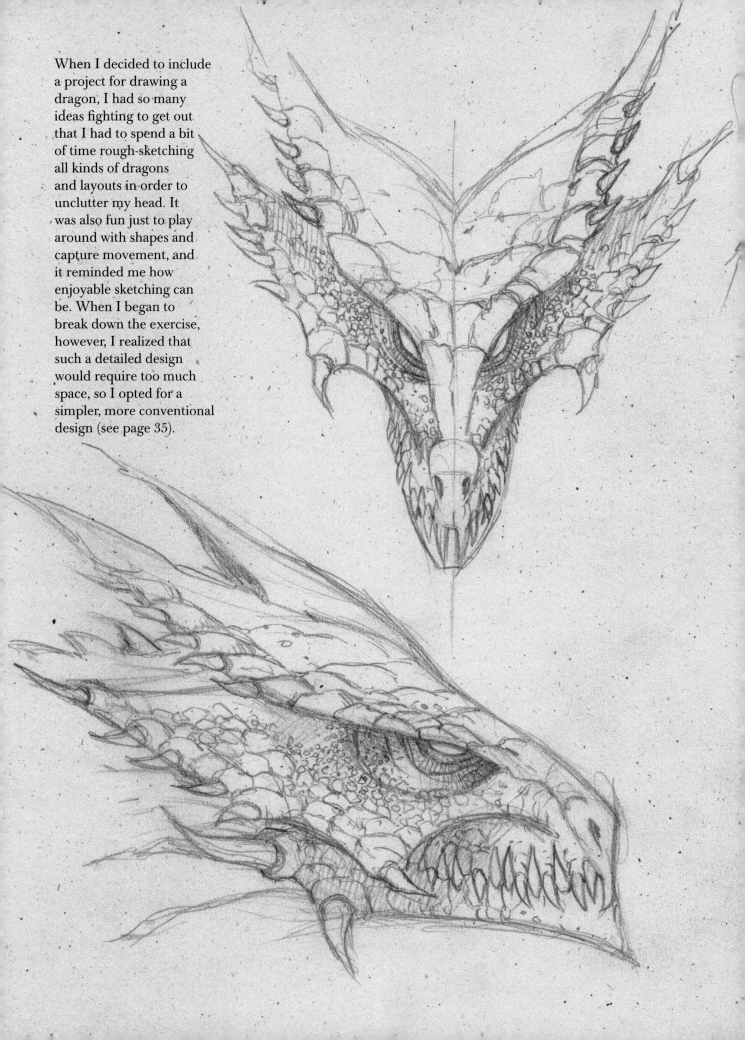

When I decided to include a project for drawing a dragon, I had so many ideas fighting to get out that I had to spend a bit of time rough-sketching all kinds of dragons and layouts in order to unclutter my head. It was also fun just to play around with shapes and capture movement, and it reminded me how enjoyable sketching can be. When I began to break down the exercise, however, I realized that such a detailed design would require too much space, so I opted for a simpler, more conventional design (see page 35).

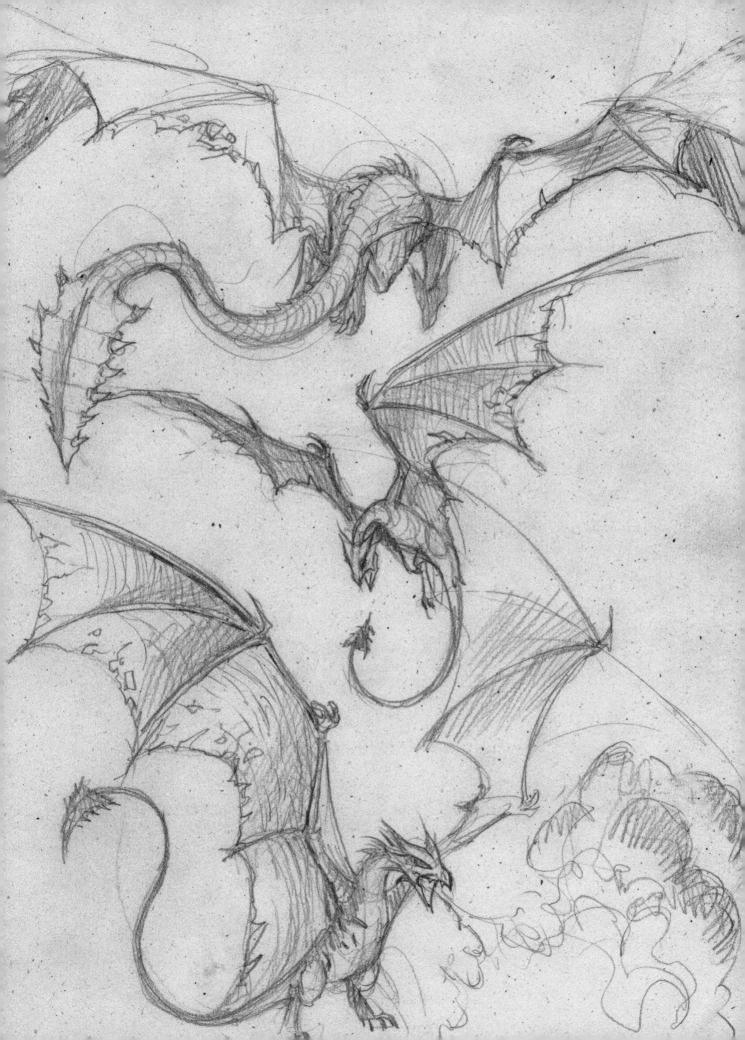

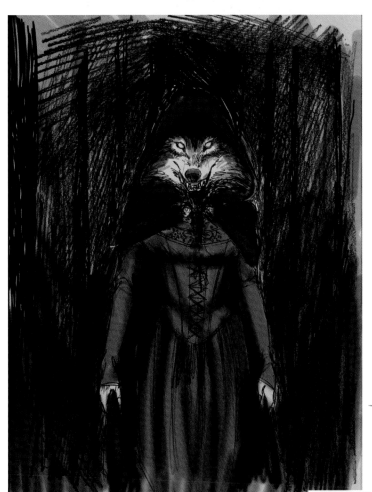

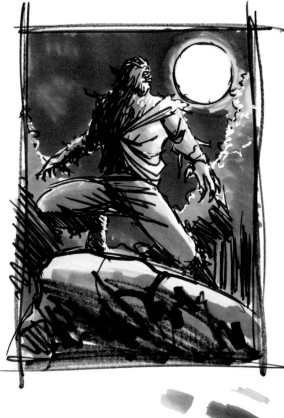

I wanted to play with the imagery of the story of Little Red Riding Hood, subverting the idea of an innocent little girl and replacing it with something altogether more predatory. I have long been a fan of Neil Jordan's 1984 Gothic fantasy-horror film *The Company of Wolves*, a resonant portrayal of a young girl's immersion in fantasies where sexuality is both scary and seductive, and I guess the images shown here are the result of this influence.

First, I drew the images on paper using pencil, then scanned and imported them into Photoshop so that I could play around with the color schemes. Computers are great for exploring and developing ideas using the same image as a template. I produced the large image on page 123 in charcoal on a piece of blue textured paper; this was taken from a promotional sample pack of paper manufactured for packaging that I happened to have. It is not always necessary to use specific types of paper or certain materials, and some of the best and most creative results occur when you are inventive with materials and use whatever is on hand.

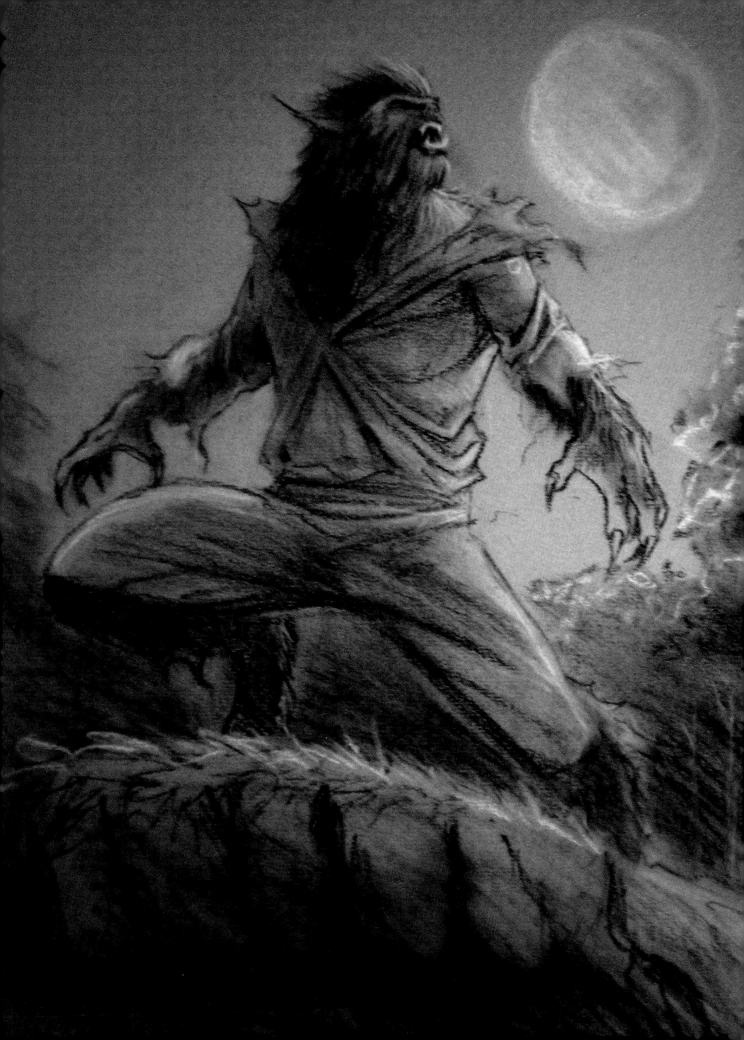

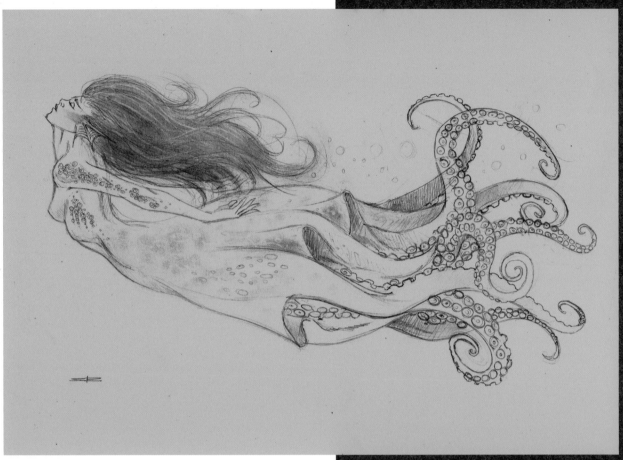

Sometimes I may find a piece of
paper lying around the studio and
the texture or color might inspire
an idea and prompt me to explore it
using different materials. The large
image shown here was produced using
Caran D'ache colored pencils on green
textured paper (about 200gsm). The
smaller inset picture above was drawn
in HB pencil on green card.

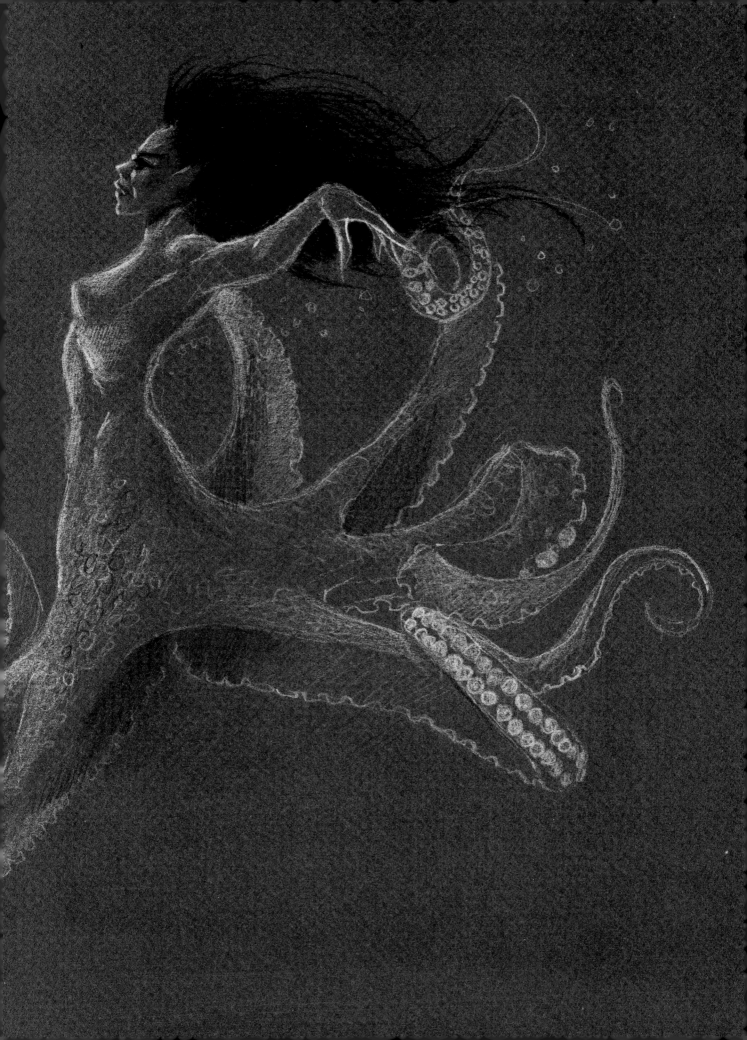

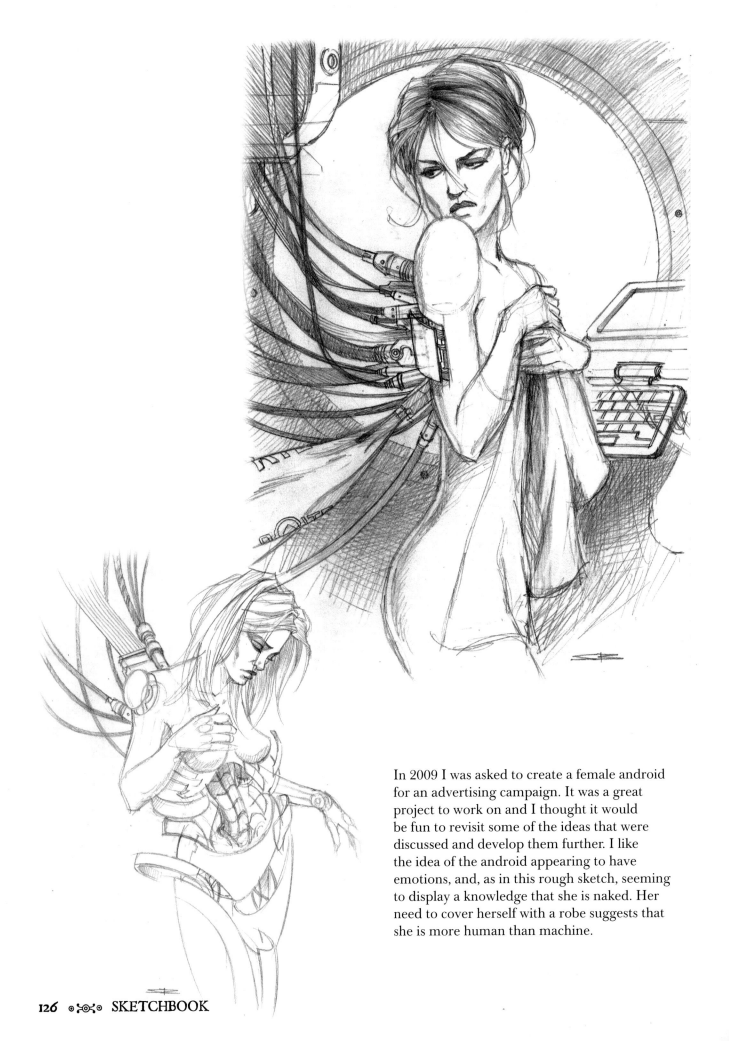

In 2009 I was asked to create a female android for an advertising campaign. It was a great project to work on and I thought it would be fun to revisit some of the ideas that were discussed and develop them further. I like the idea of the android appearing to have emotions, and, as in this rough sketch, seeming to display a knowledge that she is naked. Her need to cover herself with a robe suggests that she is more human than machine.

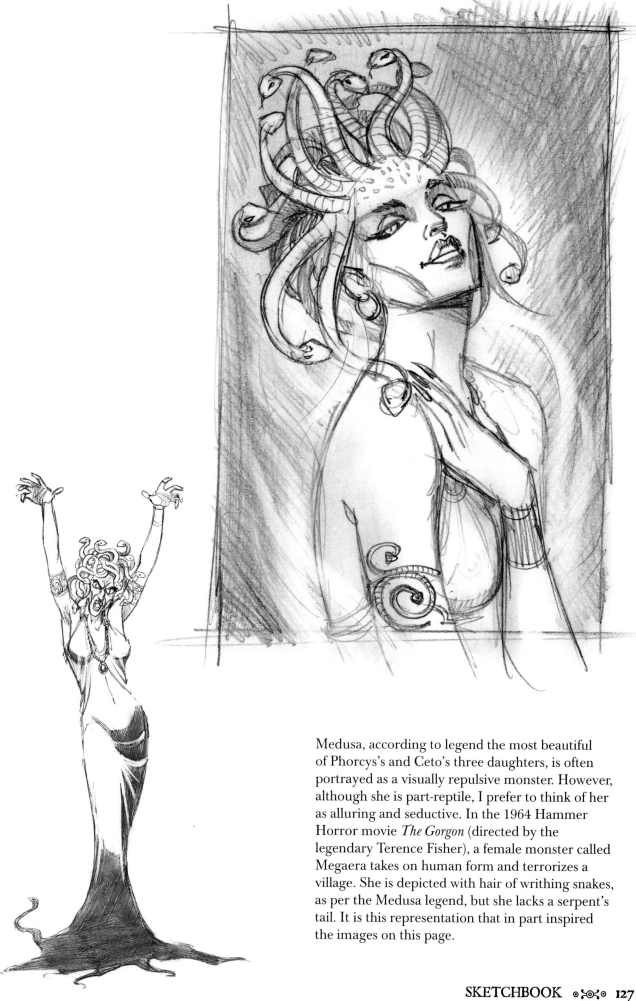

Medusa, according to legend the most beautiful of Phorcys's and Ceto's three daughters, is often portrayed as a visually repulsive monster. However, although she is part-reptile, I prefer to think of her as alluring and seductive. In the 1964 Hammer Horror movie *The Gorgon* (directed by the legendary Terence Fisher), a female monster called Megaera takes on human form and terrorizes a village. She is depicted with hair of writhing snakes, as per the Medusa legend, but she lacks a serpent's tail. It is this representation that in part inspired the images on this page.